THE EYE OF THE BEHOLDER

THE EYE OF THE BEHOLDER

by HEINZ & ELIZABETH BERTELSMANN

Introduction by JOHN CANADAY

HUDSON HILLS PRESS NEW YORK

First Edition

© 1981 by Heinz and Elizabeth Bertelsmann
Introduction © 1981 by John Canaday

All rights reserved under International and Pan-American
 Copyright Conventions
Published in the United States by Hudson Hills Press, Inc.
 Suite 4323, 30 Rockefeller Plaza, New York, N.Y. 10112

Editor and Publisher: Paul Anbinder
Copy-editor: Ann Adelman
Designer: Jos. Trautwein, The Bentwood Studio
Composition: U.S. Lithograph Inc.
Manufactured in Japan by Toppan Printing Company

Library of Congress Cataloguing in Publication Data
Bertelsmann, Heinz, 1908–
 The eye of the beholder.

 1. Photography, Artistic. 2. Bertelsmann, Heinz, 1908–
3. Bertelsmann, Elizabeth, 1909– . II. Title.
TR654.B475 779'.092'2 81–6396
 AACR2
ISBN 0-933920-20-2

CONTENTS

INTRODUCTION

THIS BOOK makes its appearance at a curious moment in the history of interplay between painting and photography, a moment critical enough to demand that any introduction to *The Eye of the Beholder* must begin by pointing out that the eye of the beholder in this case sees through the lens of a camera. Whatever resemblances the images on these pages may bear to abstract painting—and the resemblances are immediately apparent—they are primarily revelations of the visible world, revelations of a kind possible only in photographs.

The relationship between painting and photography has never been an altogether comfortable one, having been based, as it had to be, on sibling rivalry. In its short life, photography has run the typical younger-sibling gamut from hero worship and imitation in early "art photographs" to adolescent rejection and rebellion in search of its own identity. In the consequent confusion of values, "It looks just like a painting!" has been (and still is) either praise or damnation for a photograph, just as "It looks just like a photograph!" has become, within the last few years, either praise or damnation for a painting. It all depends on your point of view.

It would seem that the perfection of photographic color processes that have made books like this one possible should have brought painting and photography closer together. Instead, aesthetic issues based on territorial imperatives have become more urgent. Purists interested in establishing an independent aesthetic for photography lament the camera's increased range; the limitation of black and white, according to purist ideas, was not a limitation at all, but the single characteristic of photography that, above all others, led photographers in directions closed to painters. By an odd twist, color photography's most drastic effect has not been to bring photography "up to" (as some painters would say) the level of painting but to bring painting "down to" (the same painters would say) the level of photography.

Painters in the current photorealist movement begin with photographs and end without departing very far from them.

Photography has always served painters as an aid, primarily as a source of reference material, but sometimes by supplying technical assistance as well. If we go back to the *camera obscura* as diagrammed (but not invented) by Leonardo da Vinci in 1519, we can push back as far as the Middle Ages photography's period of junior-sibling servitude. The *camera obscura* or "dark chamber" was a device similar in principle to the simplest modern box camera (does anybody here remember the old 2-A Brownie?) except that light-sensitized film and paper had yet to be invented. The *camera obscura* focused an image from nature onto paper, where its outlines could be traced by hand, a form of instant perspective that saved many a respectable painter of city views the trouble of figuring things out by geometrical formulas. Lantern slides today with their immensely more detailed clarity are serving whole schools of realist painters in the same way. Which brings us to the very curious moment of the immediate present and, shortly, to the photographs in this book and their possible debt or possible contribution to certain standards established by painting.

It was not until 1965 or thereabouts that photorealist painters reversed their sibling relationship to photographers. Whereas the younger sibling had once striven to emulate the older, the older has now said, in effect, "Anything you can do, I can do better," the idea being to turn painting into a kind of superphotography. According to an early photorealist credo, the painter's job was simply to transfer a picture from the medium of photographic print to the medium of paint on canvas (or whatever other surface). The advantage of the transfer was never made entirely clear, but ultimately any explanation was based on the assumption that the transcription of a laboratory product that could be pro-

duced by the thousands into a unique hand-made object imposed a fundamental psychological difference in our way of responding to virtually identical images.

The variations on the photorealist idea now go under such terms as hyper-realism, super-realism, and the catch-all neo-realism, but photographic values remain the foundation of the movement. True, the painters reserve the painterly privilege of cleaning up a messy spot, sharpening a fuzzy edge, eliminating an obtrusive detail, exaggerating a highlight to slick up an area, and so on, but even so they relinquish to objective camera vision their essential birthright as painters, which is to invest images with personal sensibility. By purist photographic standards, the painters are not emulating photography but violating it by committing the cardinal sin of retouching when they polish their product in such ways. We are in the odd position just now of finding more personal sensibility, more interpretive depth, in fine photographs than in most of the photorealist-derived paintings now in vogue.

Perhaps what we are seeing at this curious and possibly critical moment is not so much a reversal of sibling roles as a meeting on common ground. Photorealism can be seen as a revolt against the autocracy of abstraction in the 1950s and 1960s (a revolt initiated by pop art, if we must give first credits in its genealogy). But if this is a matter of reaching common ground, then obviously the photographs in this book, which at first glance seem to be abstract paintings, are approaching the sibling reconciliation from the opposite direction. The question then becomes, what do they have to offer that abstract painting does not and what sacrifices of purist standards in photography are involved?

What we have here are photographs of rocks, lichens, water, leaves, weathered boards, blistered paint, and other familiar fragments of the visible world. But by means of devices consisting primarily of selection and arbitrary placement within borders, these elements have been disguised to resemble a type of freely painted abstraction that has undergone a process of crystallization. "Disguised" is not a good word, however; along with the translation into abstract patterns there is as well, and more importantly, not a disguise but a revelation of natural colors, patterns, and textures that the acute eye of a fine lens can record in more precise detail than our own eyes can perceive. The images are deliberately isolated from natural contexts for the double purpose of establishing an arbitrary design within the photographs' boundaries and intensifying our perception of ordinary things. In the end they are not abstractions, but subject pictures.

It is possible that painters dedicated to abstraction may feel that these photographs invade their territory by borrowing the surface decorative appeal of abstract expressionism while sacrificing its intellectualism to specific images as subject matter. In that case, it can be pointed out that Robert Motherwell, the philosopher, spokesman, dean, and most eminent living practitioner of abstract expressionism, insists that his art, "far from being abstract in any Utopian sense" (as the critic Robert Hughes puts it) is an art of subject matter. Hughes specifies "walls in white light, the salt-white clapboard walls of Provincetown on the rim of its blue bay, the grainier and thicker walls of Cadaques or Nice with their dark recesses and calligraphies of noon shadow" as some of Motherwell's subjects in his "lyric mode." Any of these could also have served Heinz and Elizabeth Bertelsmann as subjects for the lens/eye of their camera/observer. If their "mode" is less lyrical, it is more magical in its revelation of the miracle that surrounds us, the visible world.

I cannot see that any significant conflict, or even compromise, is involved. Abstract painting indulges to the final degree the artists' inherited territory of personalism and intellectual introspection; the photographic eye remains objective. If the first, momentary response to these photographs is simply visual delight, what is rewarding in the end is their presentation of subject matter for our consideration in forms unfamiliar enough to stimulate new responses to nature. We need not try to fathom the painter's hidden responses; we have the privilege of enjoying our own.

JOHN CANADAY

THE EYE OF THE BEHOLDER

IN PHOTOGRAPHING the world around us—people, villages and towns, forests and mountains, lakes and streams—we have become aware of what is usually unseen, of visual experiences usually ignored.

We found excitement and elation in discovering and recording the interaction of forms, shapes, and colors that occurs everywhere in our surroundings but is generally not perceived. Textures, designs, and patterns are inherent in rock walls and tree trunks, they flow in water, are crystallized in hoarfrost and ice, and appear in time, when nature has its way, on man-made surfaces and structures. Nature creates imagery that transcends subject matter. It is ours to enjoy—if we will but attune ourselves to it.

At the seashore we first became entranced with shapes within shapes, with the structure of a rock spur, geometric lines on boulders, folds of granite, brittle textures of lichen, color harmonies in tidepools. Hitherto unobserved images were revealed. From our lasting enjoyment of more traditional scenery, fauna, and flora, these discoveries emerged with an increasingly powerful force of their own to add new poignancy to our visual world wherever we went.

Sometimes it is the interplay of lines and tones, the rhythm and tension in the tracing of time and weather on exposed surfaces, that intrigues us; or we might discern semblances of archetypal figures, human and animal, drawn by natural forces, predating all art. When we open ourselves to new impressions, certain analogies and affinities demand our attention. A stream's ripples may become a many-faceted jewel, the surface of cut wood can suggest wave patterns that are echoed in sand dunes, a phantom mask appears to surge from an old tree trunk. The resemblances to many art forms are arresting. Other images confront us with the unreal immediacy of dreams, outside the realm of our conscious visual experience.

Our perception of our surroundings is formed by our experience in the western world of the twentieth century, as well as by our absorption of stimuli from the art of many centuries and civilizations, sculpture and architecture, painting and photography. Without exposure to modern art, we would not be able to respond to the abstract in the material world.

A world of enchanted reality, of visual fascination, awaits all who allow their eyes to focus and to linger on neglected aspects of the familiar. It is our perhaps immodest hope that this book may help viewers and readers to see in a new vein and to add a new level to their perception, thus contributing to their fulfillment as sentient human beings and enriching their lives.

For many years before we met, both of us had been engaged in black-and-white photography in different ways. Elizabeth (as Elizabeth Colman) was a free-lance photographer; in addition to her work in portraiture, she contributed to magazines and is the author of two photographic books for which she also wrote the text. Heinz took pictures for his own enjoyment and participated in exhibitions and competitions in which he won prizes.

When we married, we decided to explore the possibilities of color in order to record our perceptions in the most direct manner possible, without first visualizing the scene in black and white. We renounced the stark power that black and white can impart and attempted instead to photograph the world in its multi-hued splendor.

Sobering encounters with unfamiliar problems came promptly. On a trip to the coast of Maine, we were still experiencing the texture of the sand, the granite rocks and boulders smoothed by pounding waves, patterns gouged out by the sea in horizontal strata, and deeply rutted cliffs on some of the islands through the discipline of black and white.

For a while our emotional response to the woodcut

harshness of the area made us feel that color would detract from the impact of what we could render in black and white. Then, remaining at the coast, we became more and more entranced in watching the color of the water change subtly, ceaselessly, as the clouds sailed by and wind and waves played with the reflections of rocks, trees, and bushes, whirling sand and kelp. We accepted the challenge of attempting to capture a fleeting gamut of tints. Later, delicate nuances that appeared unexpectedly on our film proved to us that we had only been able to discern a fraction of the glistening hues.

We spent hours watching the waves race in at high tide, driving against rock barriers, breaking with a roar into jets and foam, acting like prisms. As the tide receded, it left behind small pools of water in depressions on the flat rocks. At first the water seemed clear; but looking closer, when our eyes had adapted and were shielded from the glare, we saw through the translucence a rainbow of colors: steel-blue clams, seaweeds in many shades of green, rust and mauve algae, red, orange, and beige pebbles, white iridescent barnacles. When the tide was low, the waves, now softer in form and lapping quietly on the sand, fanned the kelp gently to and fro, allowing us brief glimpses of the purple rock at the bottom of a deep basin.

How were we to combine our previous experience of black and white abstraction from reality with the world of color, its symbolism, its harmonies, contrasts, and discords, with its challenge of advancing and receding hues, with new problems of tonality and composition? How would we avoid the pitfalls of garish loudness or cloying sweetness that had been nonexistent in our photographic past? We could only hope that increasing awareness and experimentation would help us to render faithfully what we felt and sought at the moment of exposure.

In retrospect, our experience at the seashore was merely the start on a route that opened up fresh potentialities. On a later trip to the Rocky Mountains, at first our principal preoccupation and delight was to record in newly found color the high ranges with their cascades, lakes, trees, and flowers. All this was a color trip away from the simplifying and demanding austerity of black and white.

In the beginning of our life with color, we still, almost as a matter of course, avoided images where closeness of unfiltered tonal values would translate into nearly indistinguishable shades of gray incapable of conveying the essence of the scene perceived. We still tended to seek light conditions and to concentrate on areas that would be enhanced by being rendered in black and white.

Then, gradually, we began to be drawn to views that spoke to us in the minor key of subtle hues. Quiet tones demanded our attention and forms appeared where before we had seen only shades of pastel. More and more of nature's less obvious manifestations entered our field of vision on our trips to the mountains and the sea. Our perception had developed and in turn stimulated our imagination. While still enjoying the "grand view," we can now also revel in the latent "hidden" image.

If we consider the reduction of a three-dimensional world into the two-dimensional frame of a slide as a first step toward abstraction from reality, and the transformation of color into black and white as the second, then we might say that in the work presented here a second step toward abstraction was taken, not by transforming color into tones of gray but by finding "camouflaged," seemingly nonobjective color images that demand to be culled from their surroundings. It is an abstraction from a tangible world of fantasy.

These images do not appear only in nature. We find them on the flat roof of our home, on the sidings of old barns, in the polished marble of skyscrapers, on rusty pieces of metal, the walls of painted houses, and torn and faded posters.

Our hope of sharing our experiences came true one day in Mexico. We had found a wall covered with weatherbeaten advertisements. Heinz took several pictures, then stepped back, looking for other designs, when he encountered a simple woman, probably with little formal education, berating us gringos for photographing decay instead of the new modern market nearby. He led her to where Elizabeth was just taking a picture. Elizabeth then explained the areas she had recorded and what we were seeing. Instantly the woman understood. "That makes a picture," she said—and her hostility gave way to acceptance. She called out to her shy companions to share her discovery and the pleasure she had found where decay seemed prevalent. At least in this instance, our wish to convey to others what we see was quite unexpectedly fulfilled.

THE EYE OF THE BEHOLDER

water_____

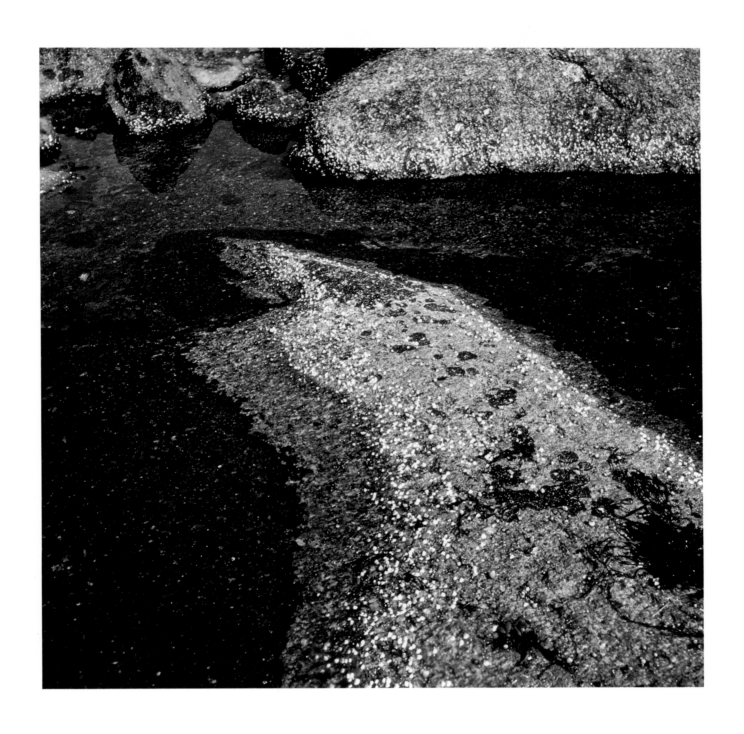

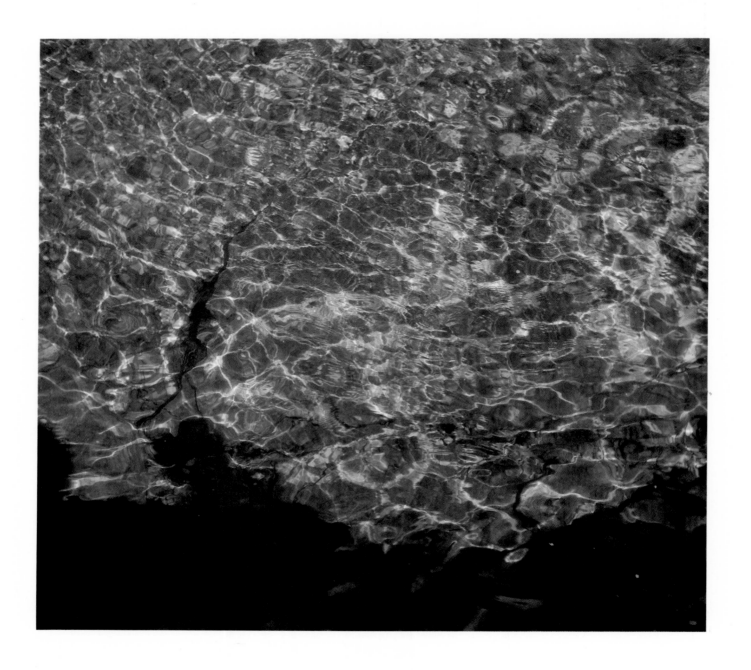

16

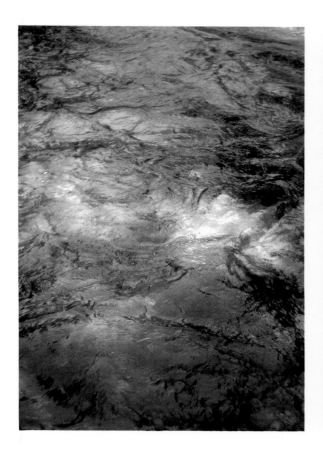
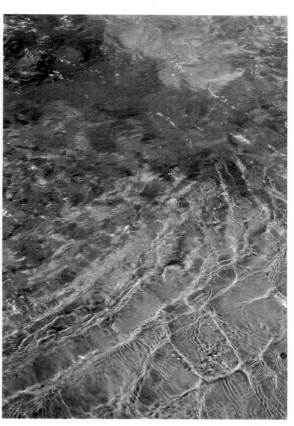
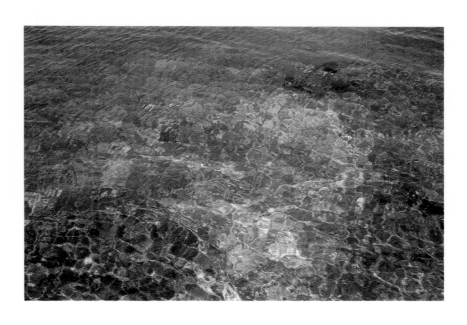

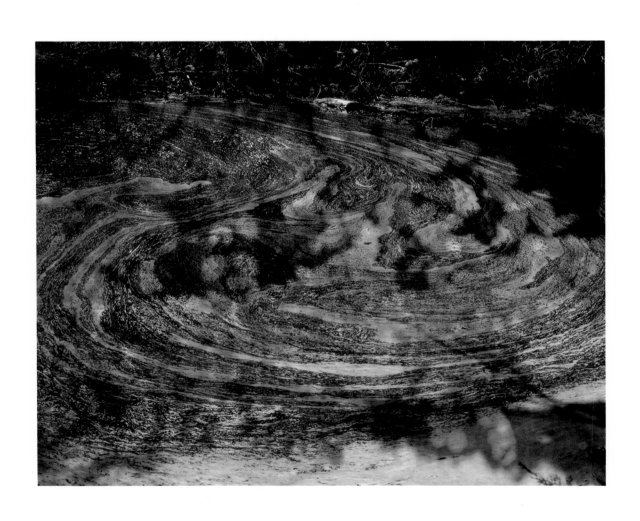

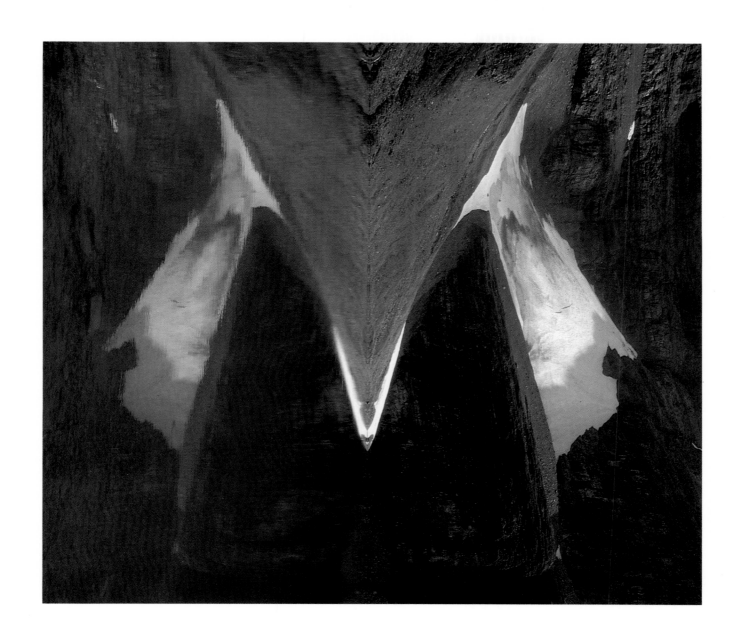

stone _____

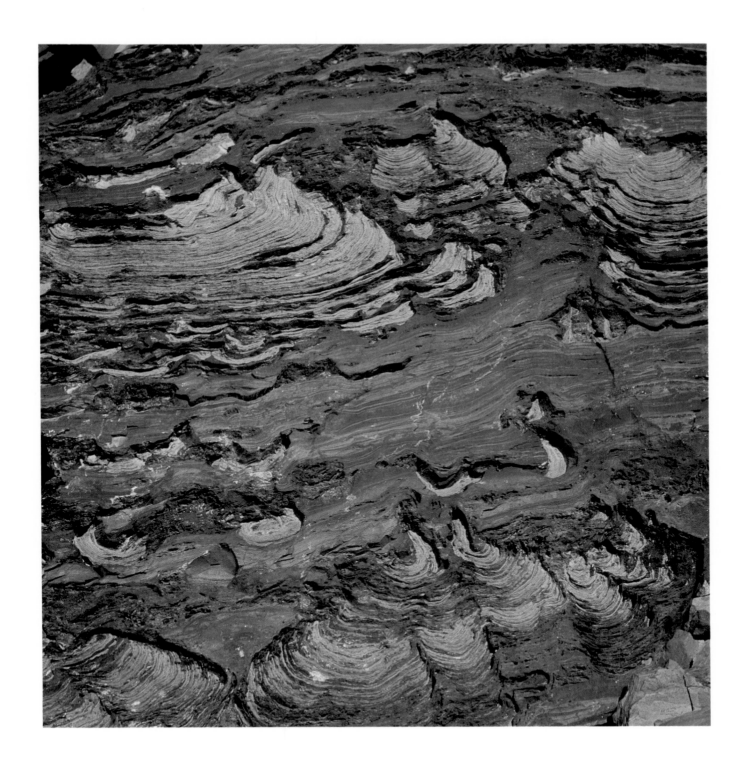

25

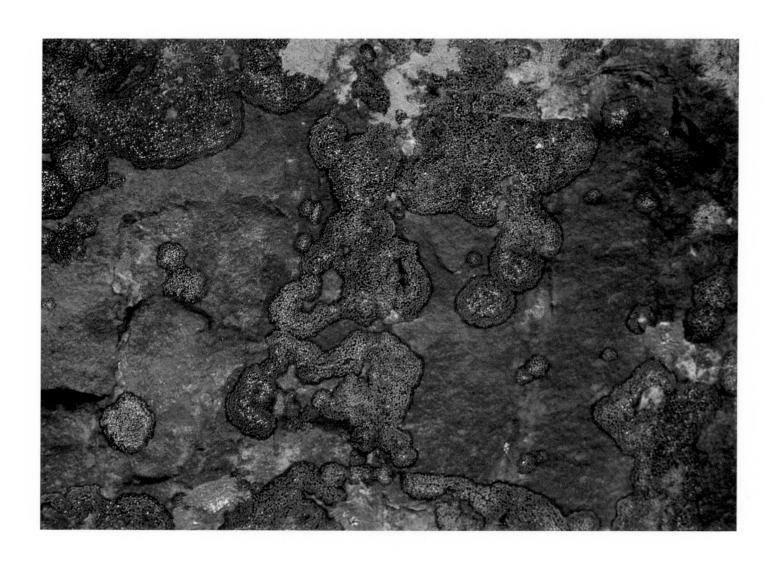

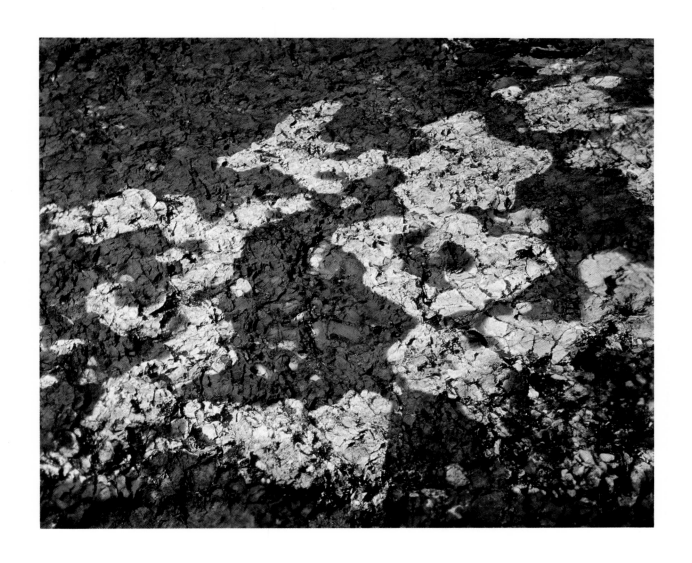

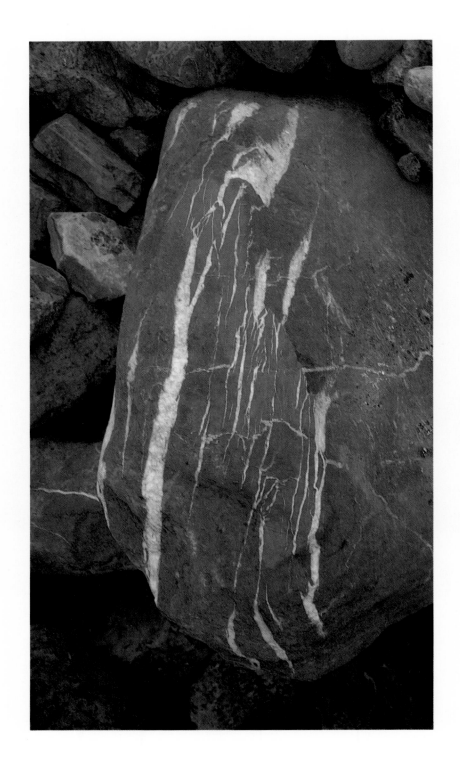

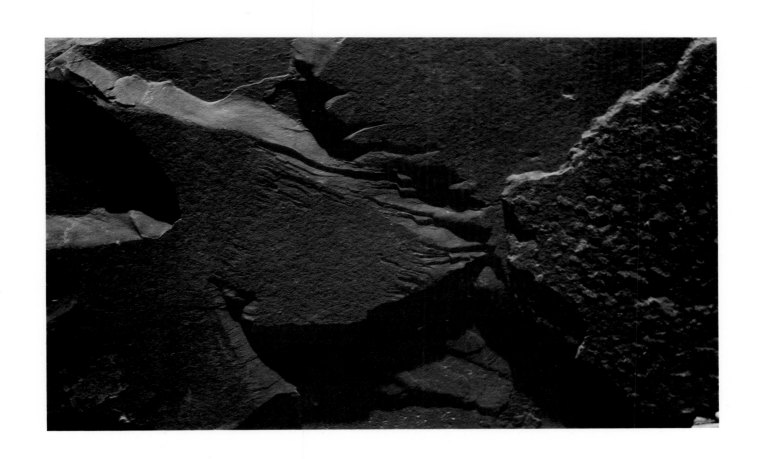

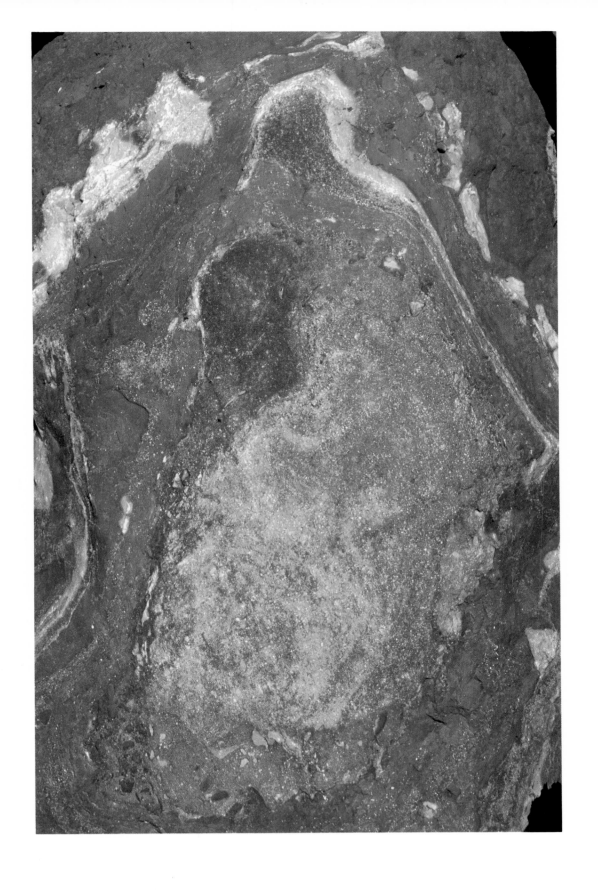

31

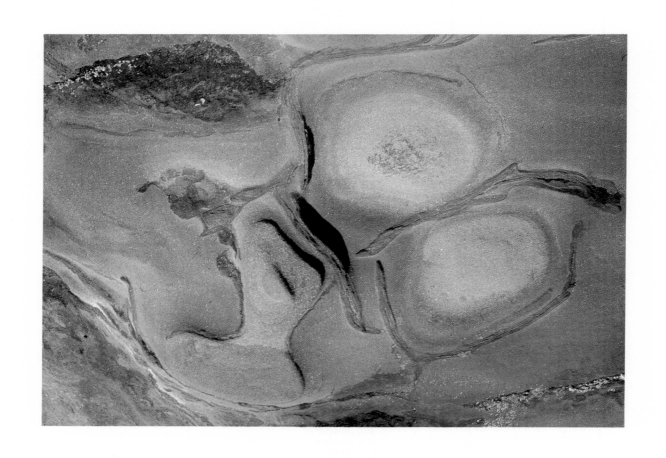

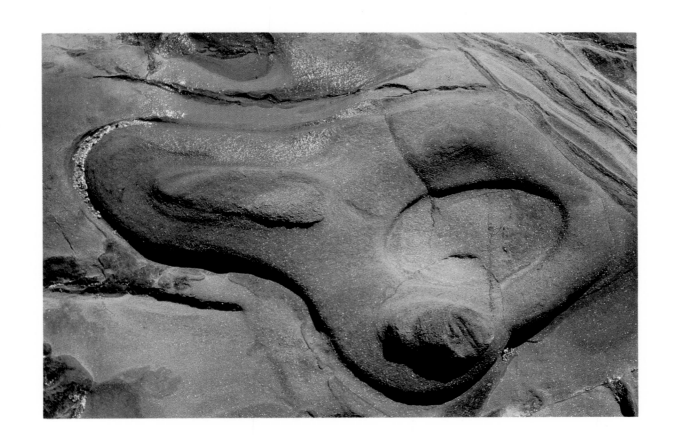

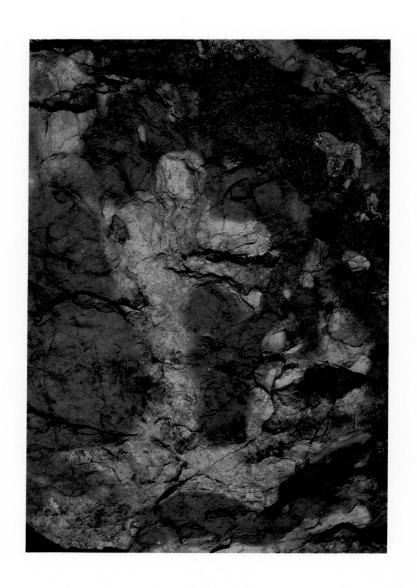

34

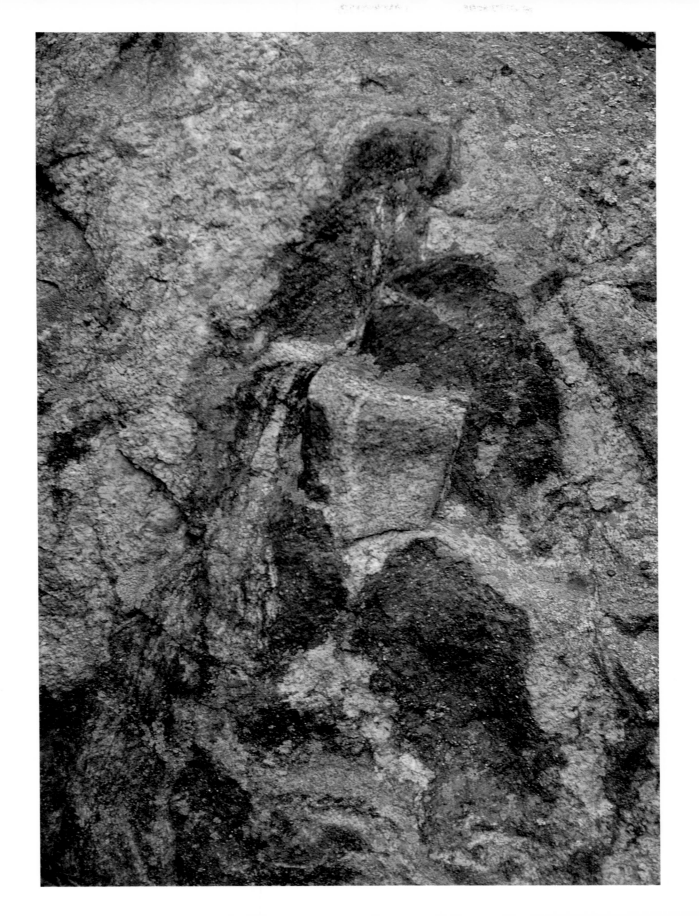

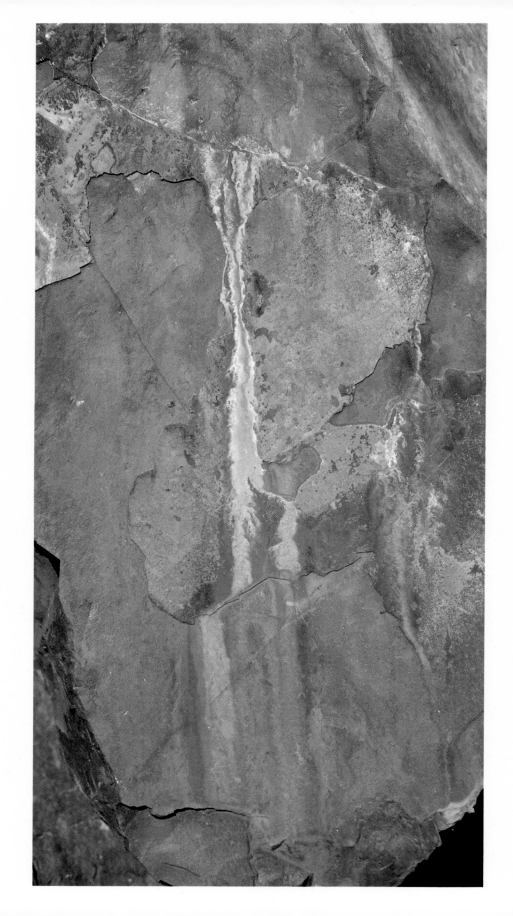

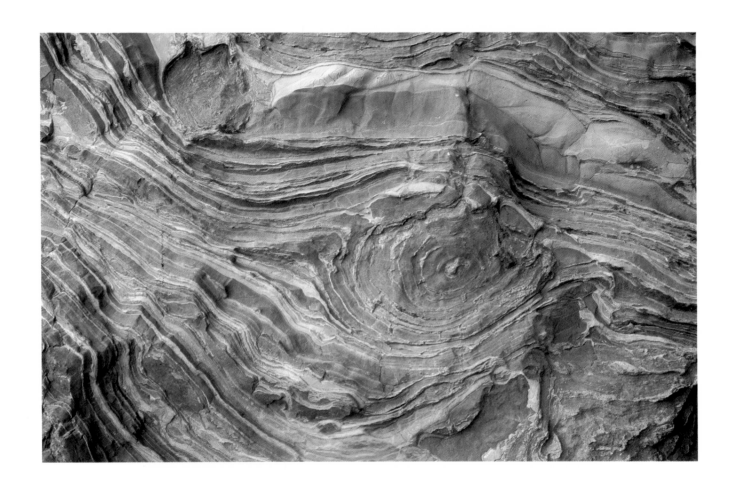

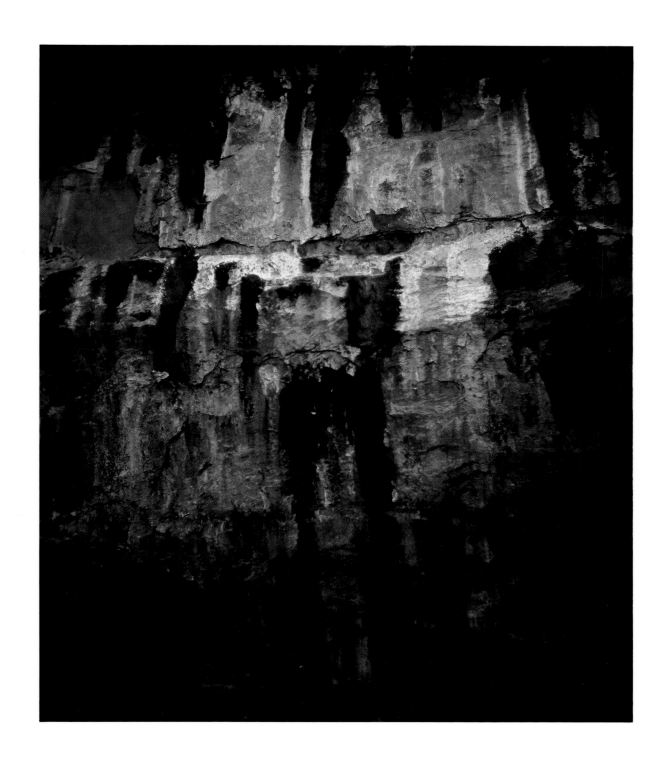

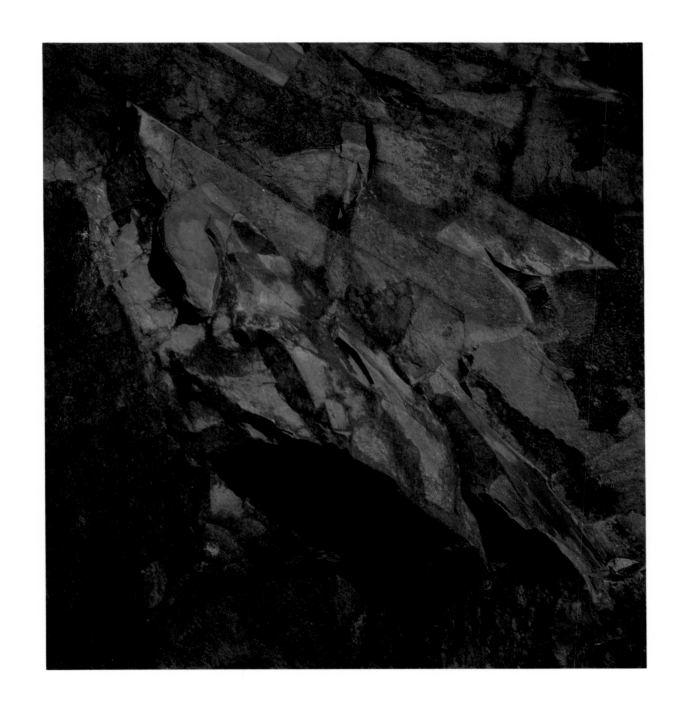

lichen & algae _____

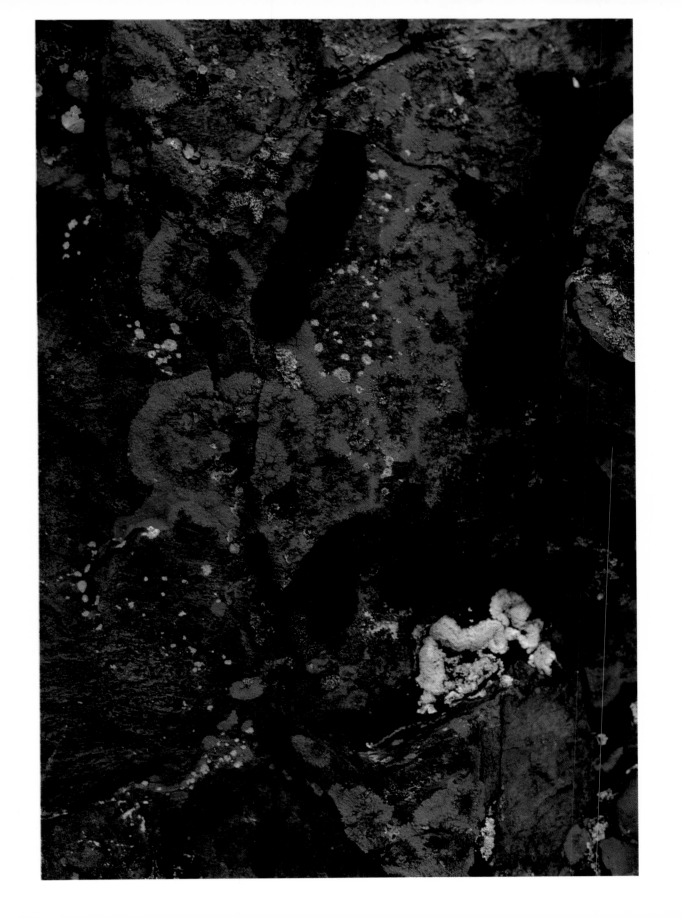

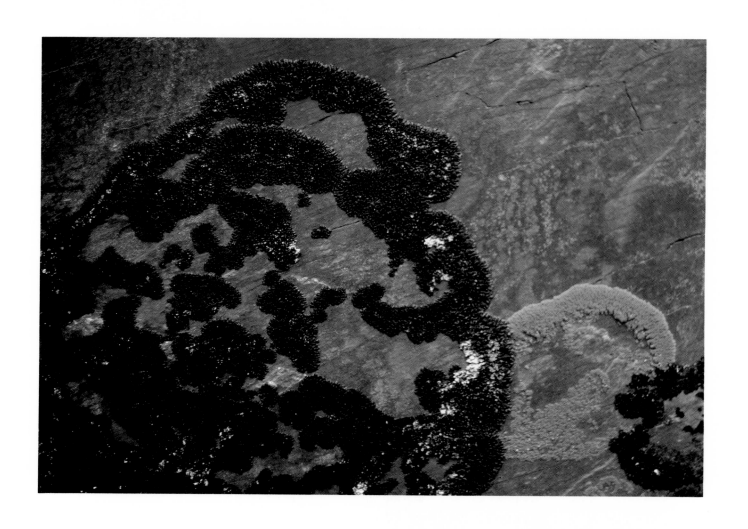

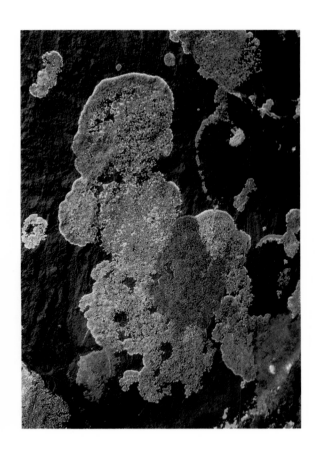

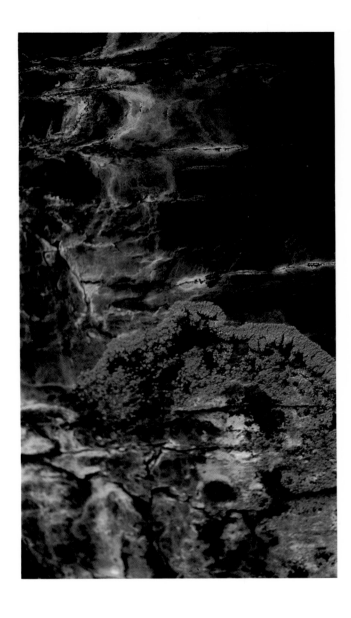

47

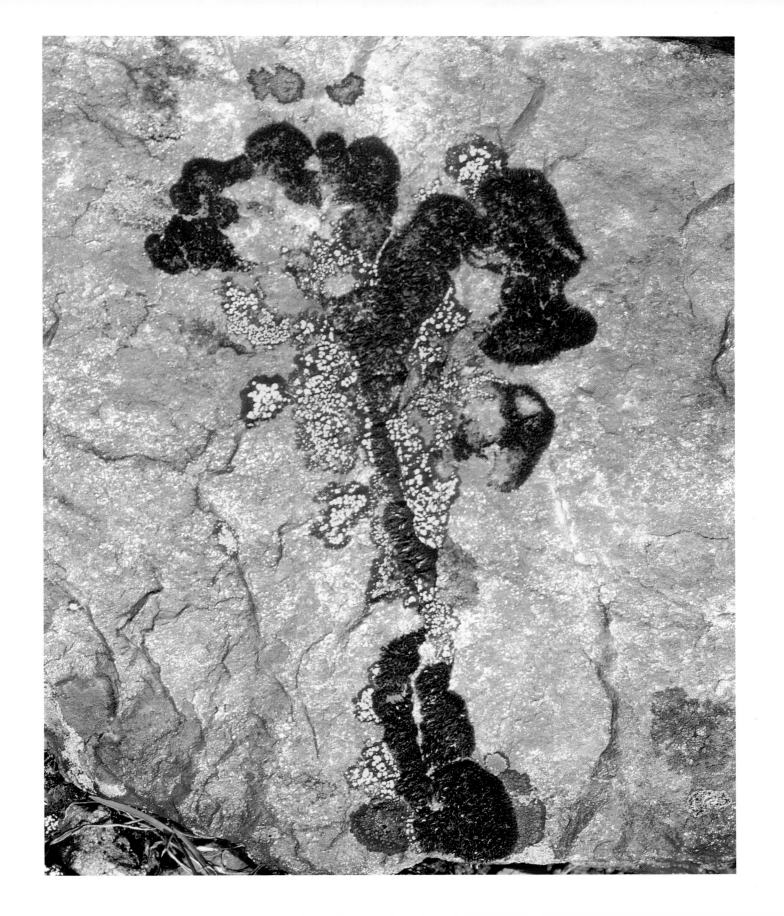

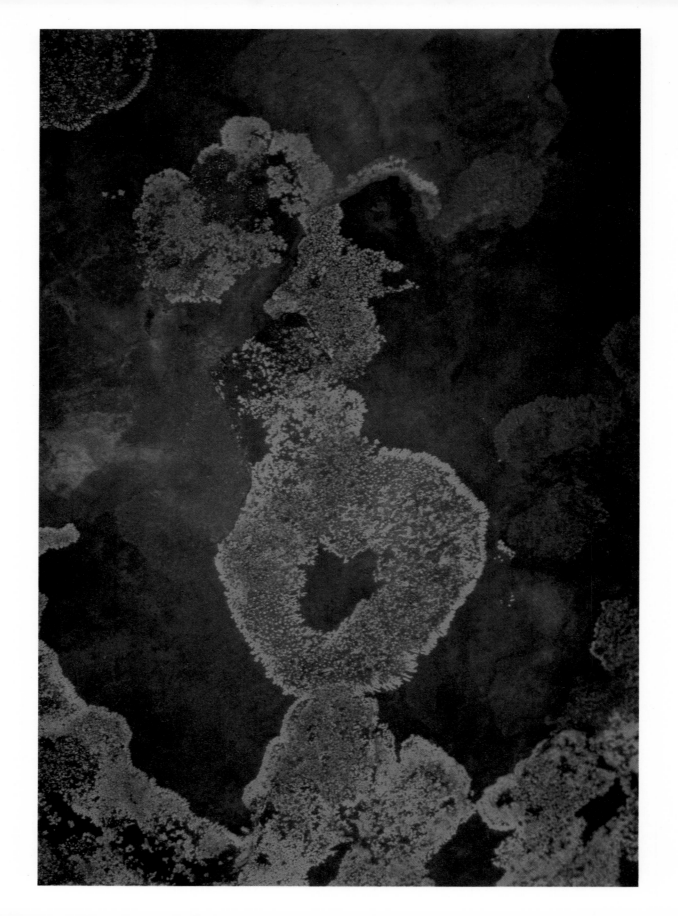

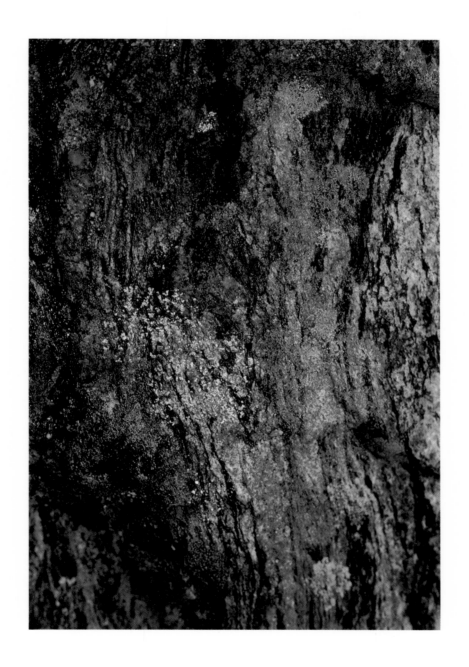

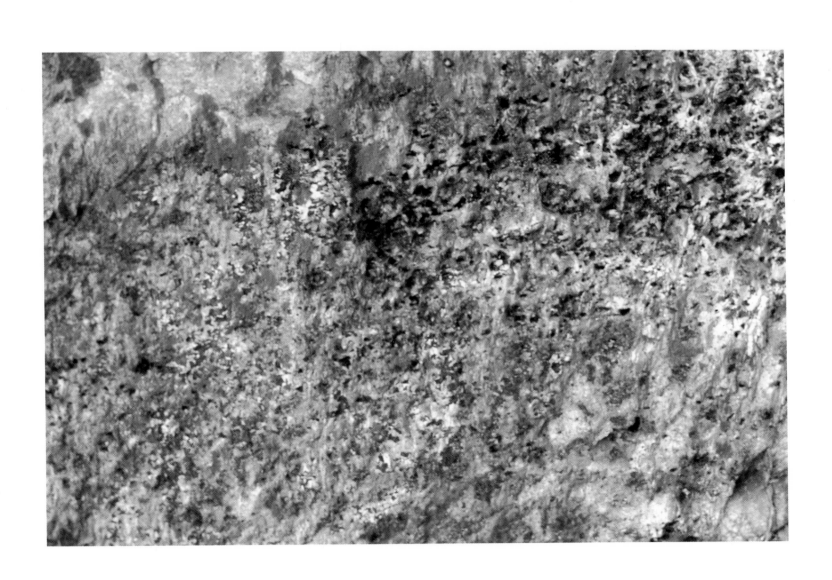

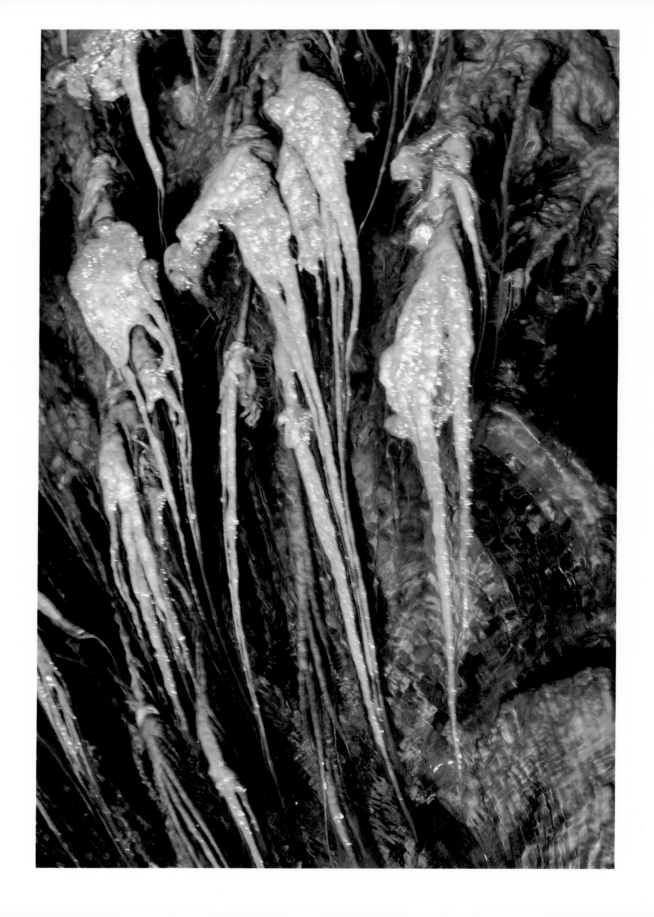

54

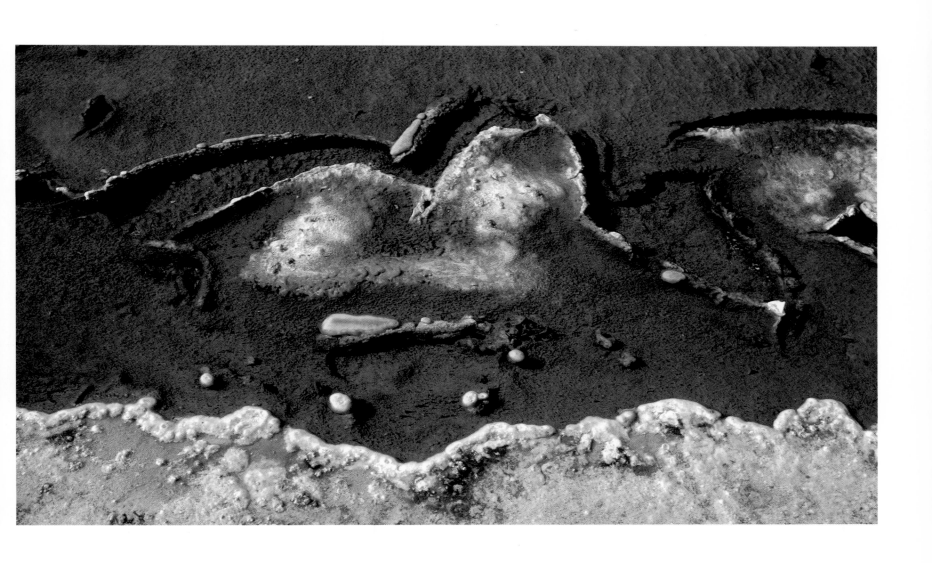

55

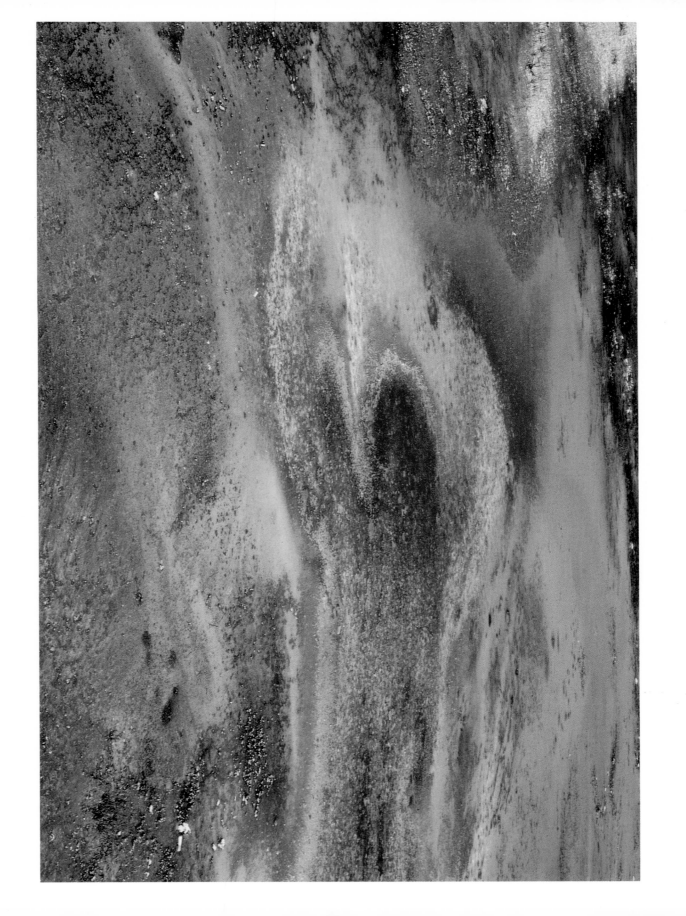

57

trees —————————————————

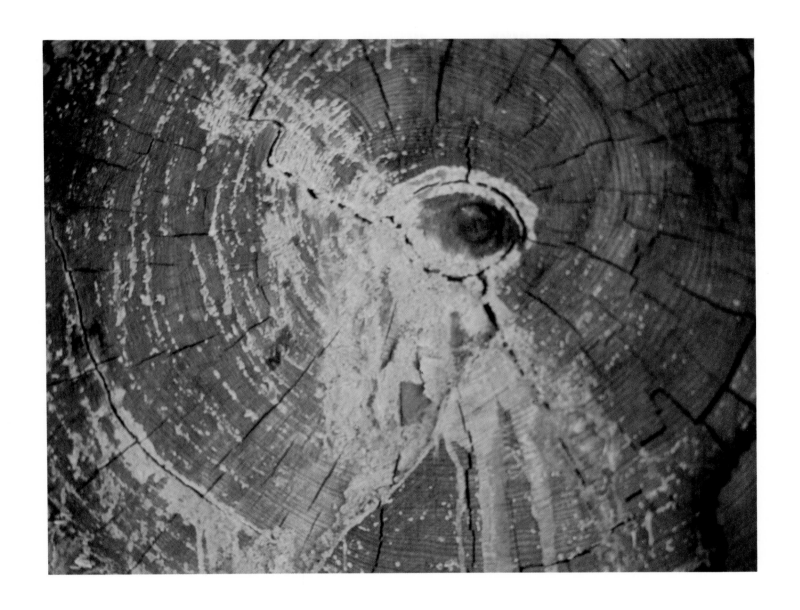

61

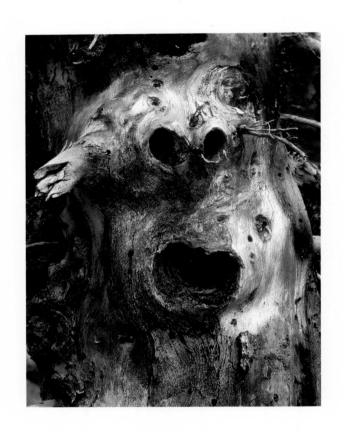

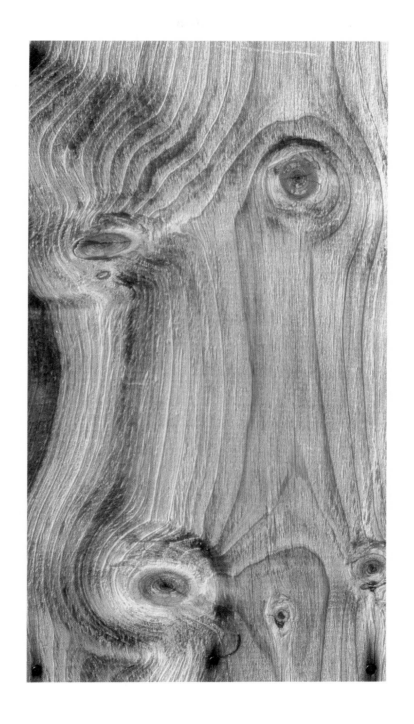

63

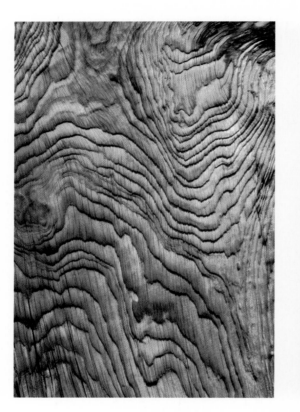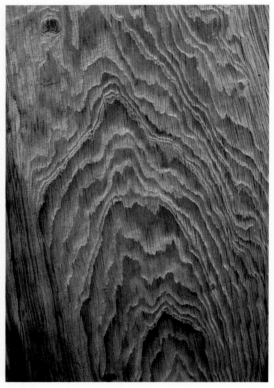

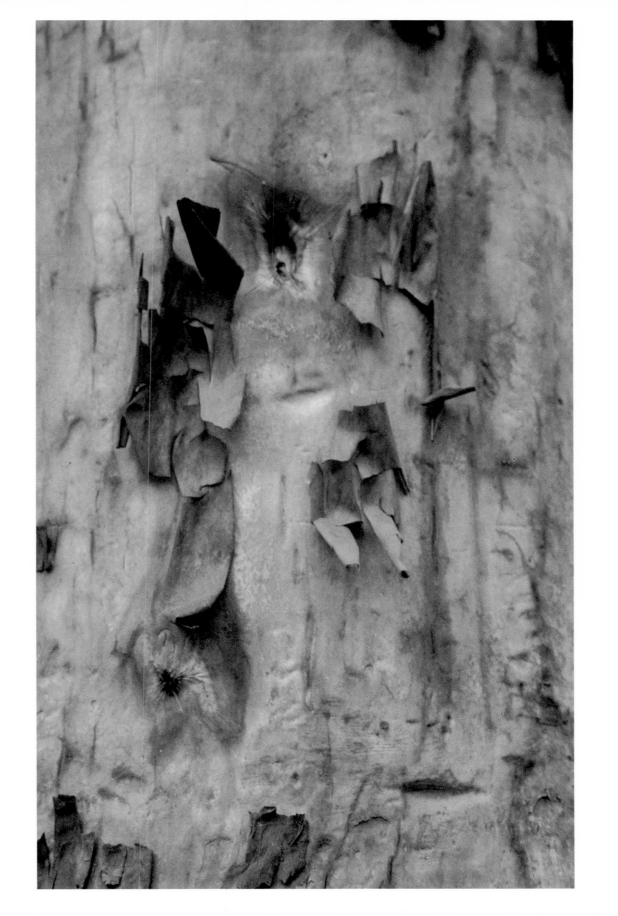

65

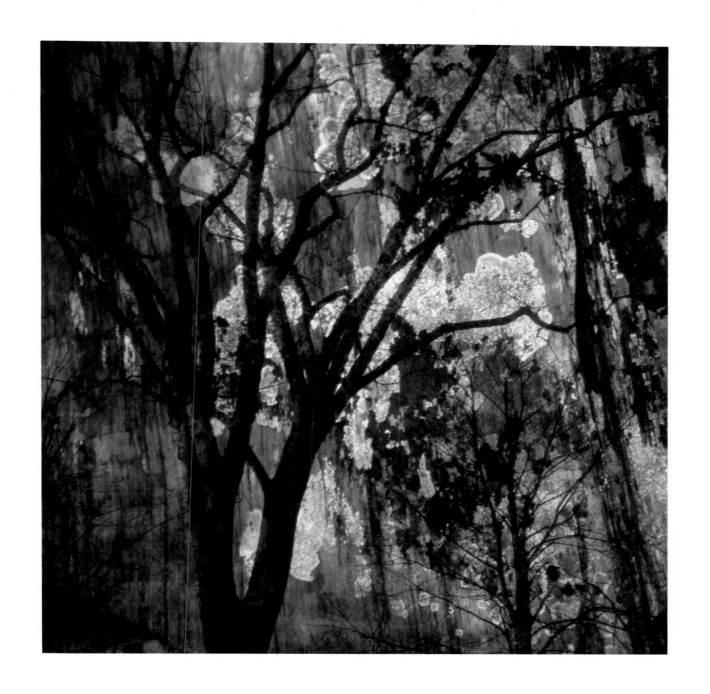

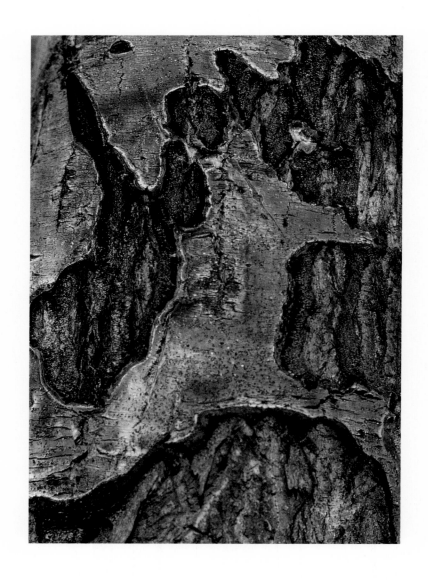

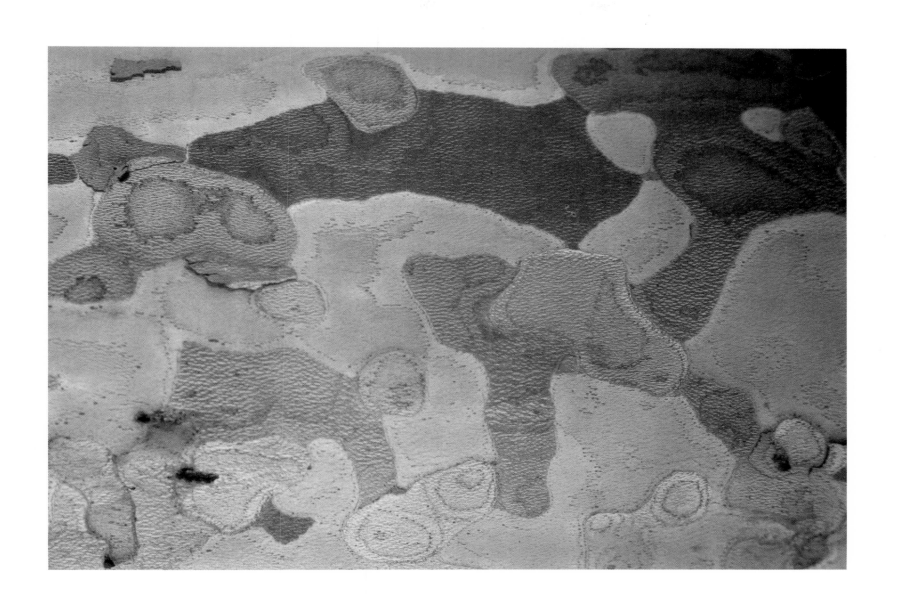

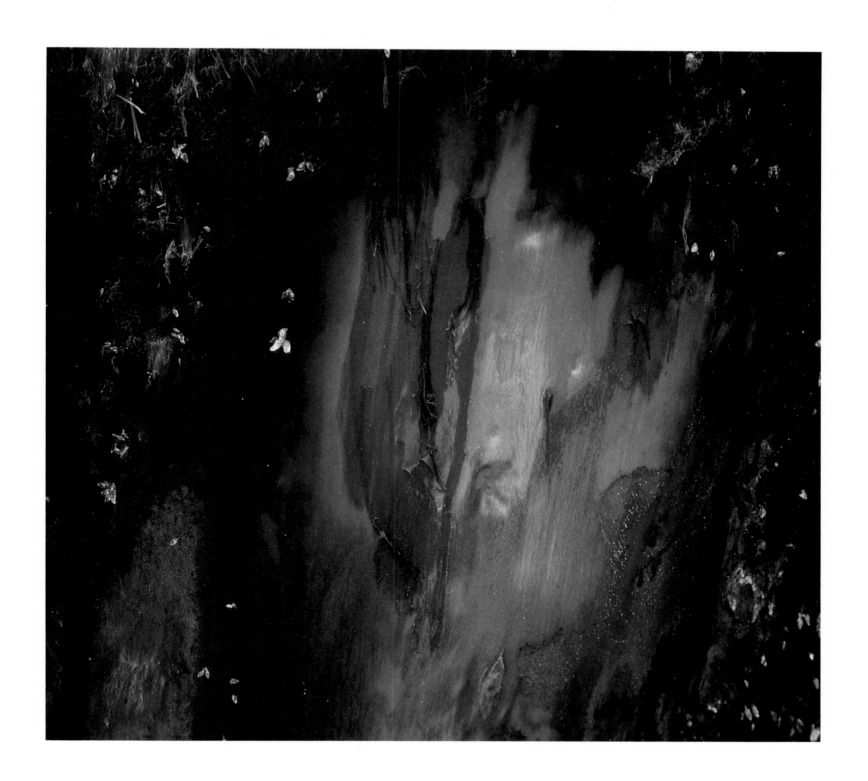

71

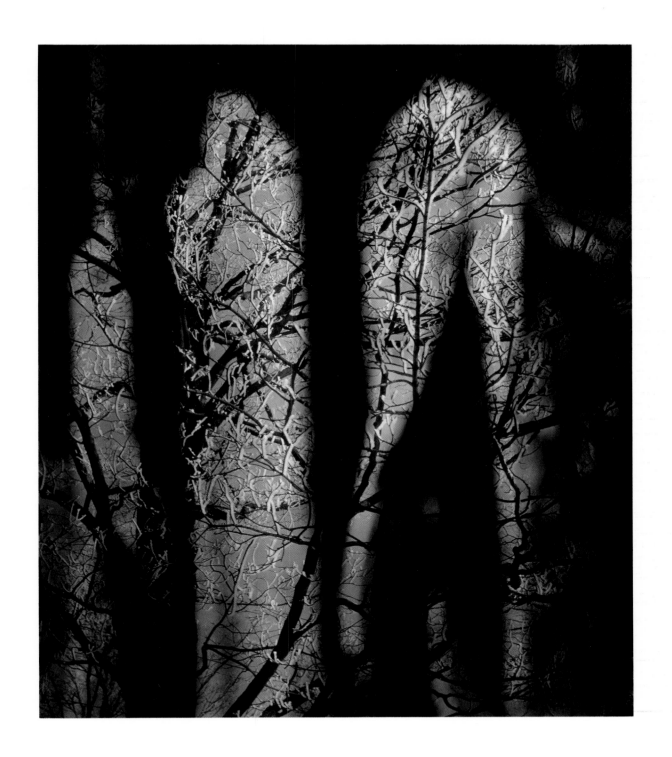

walls & sidings

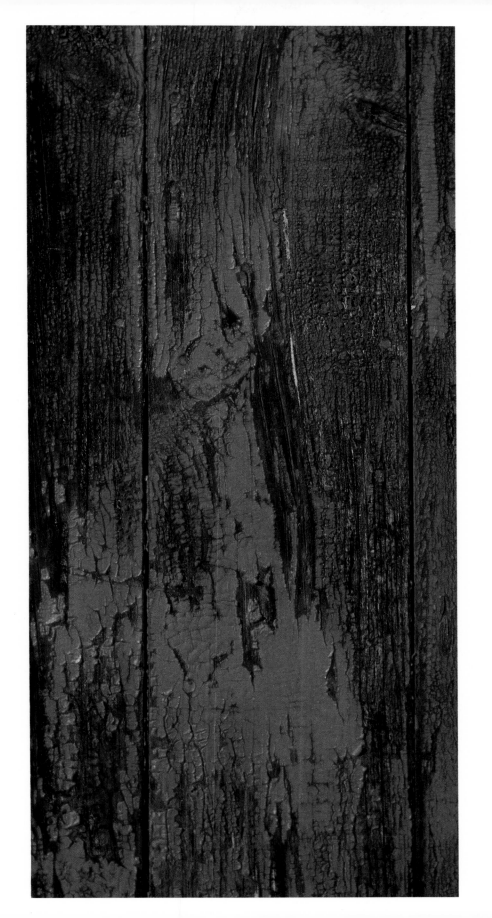

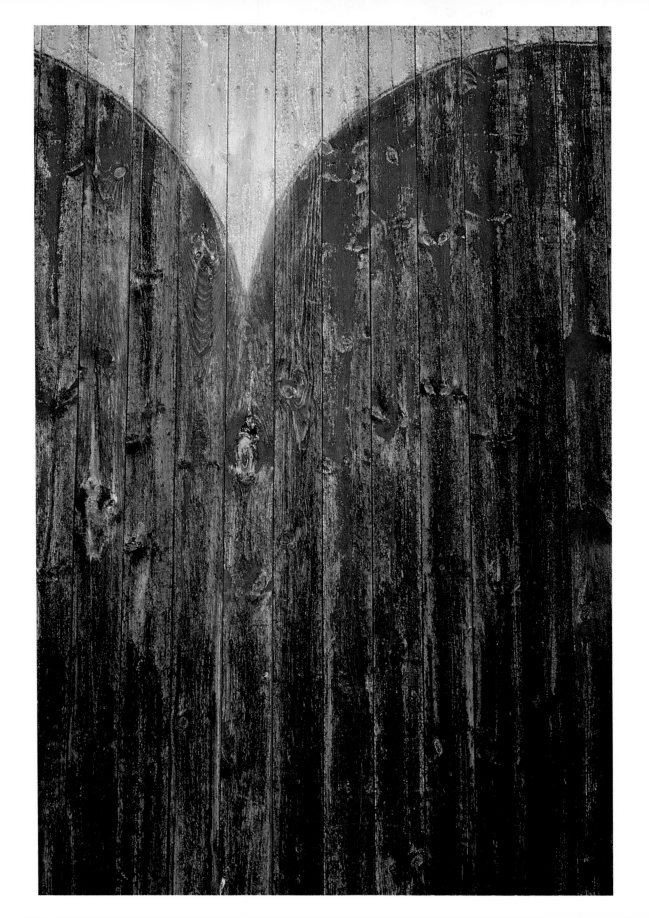

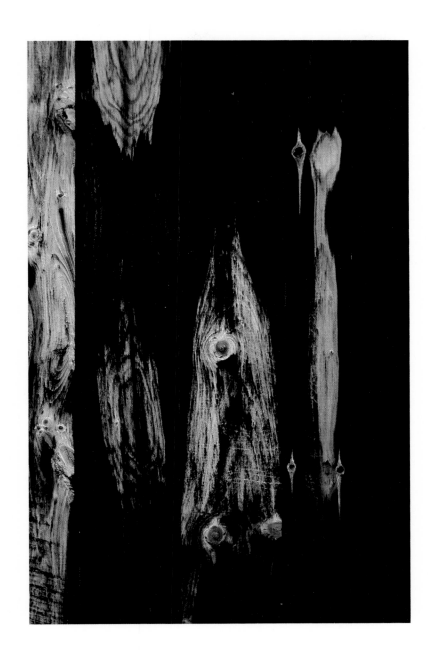

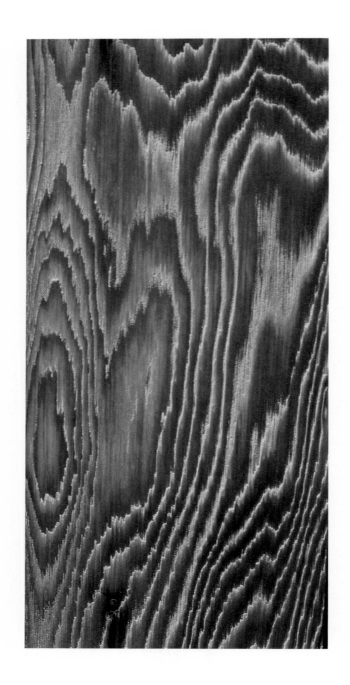

82

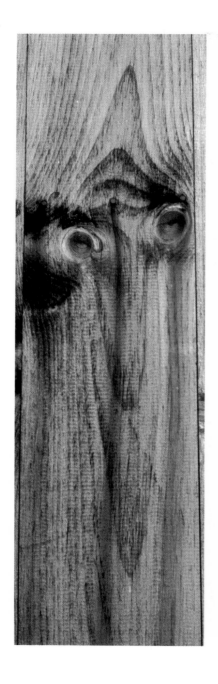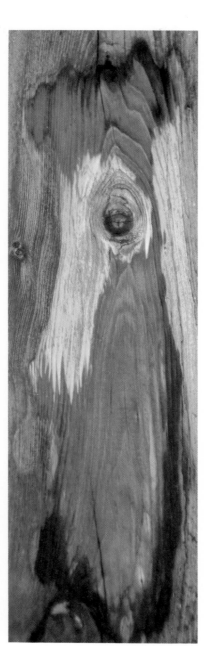

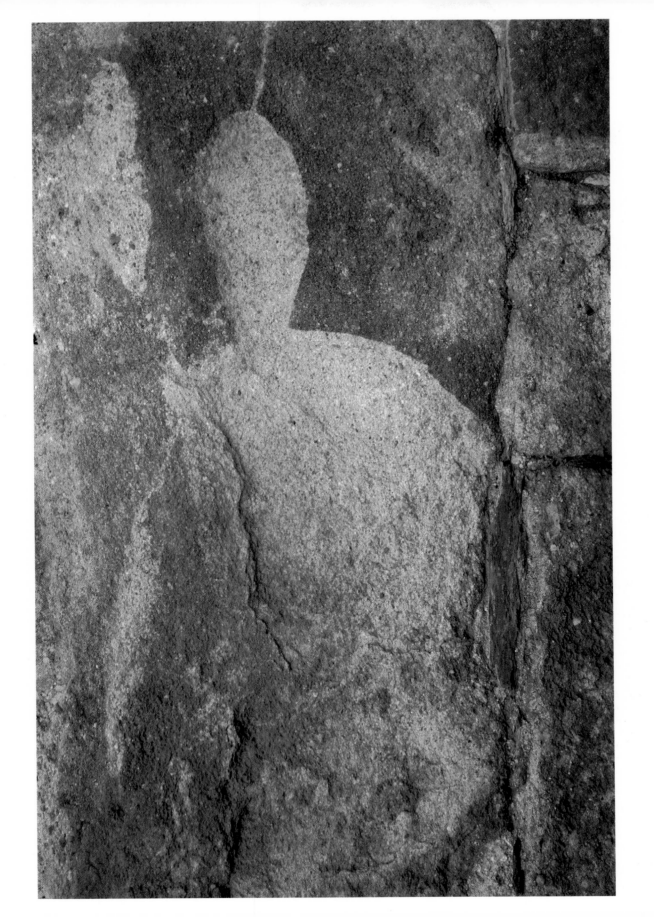

85

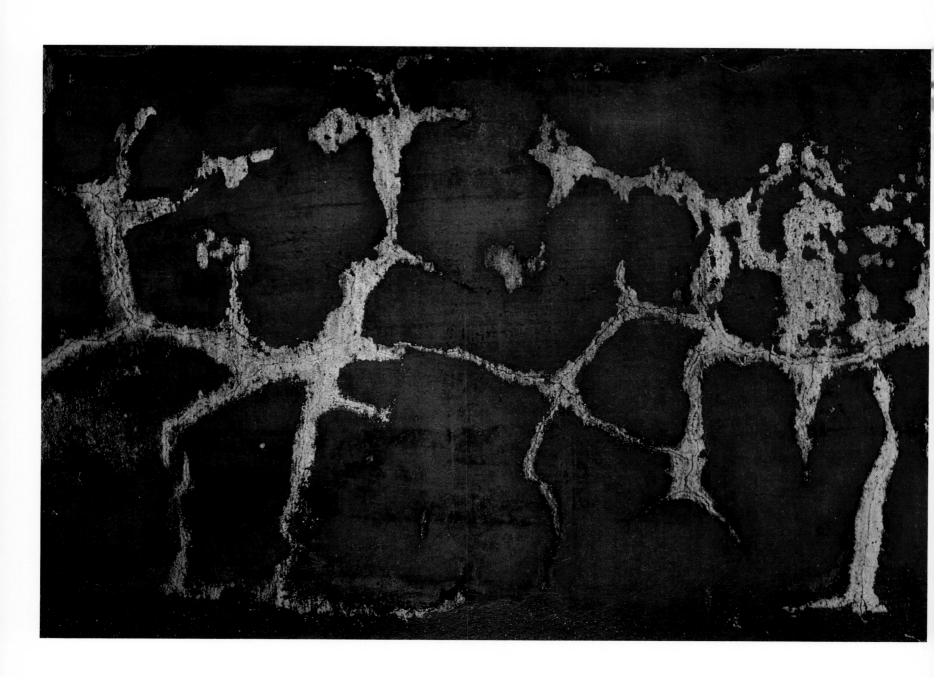

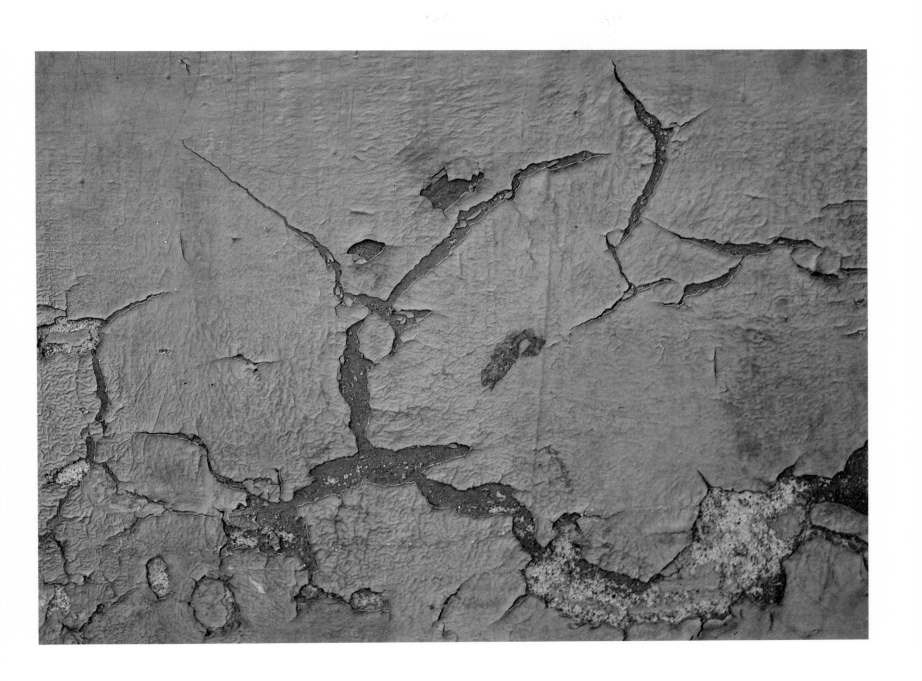

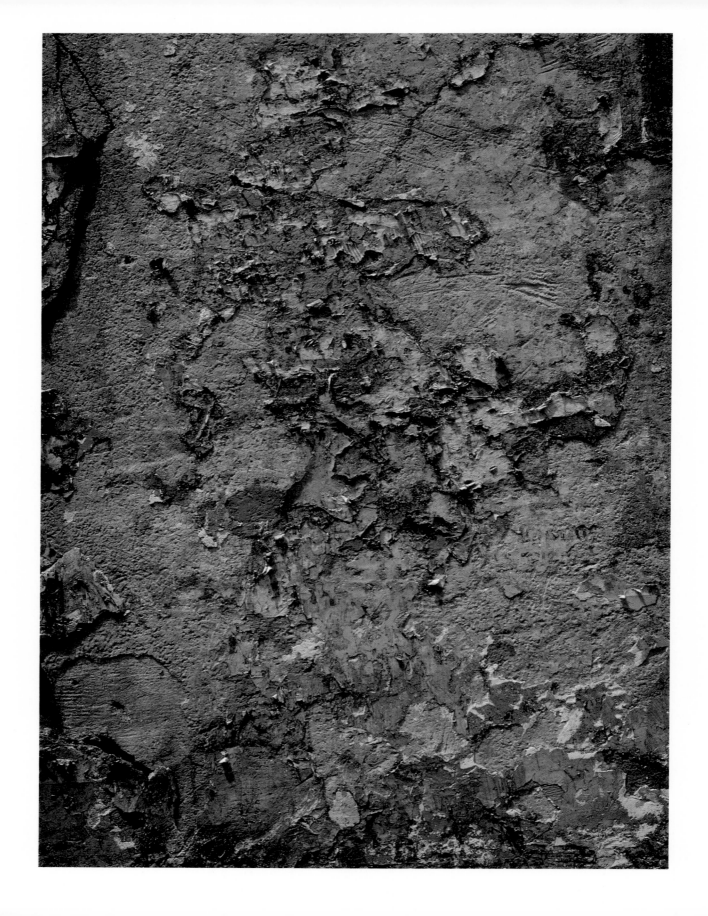

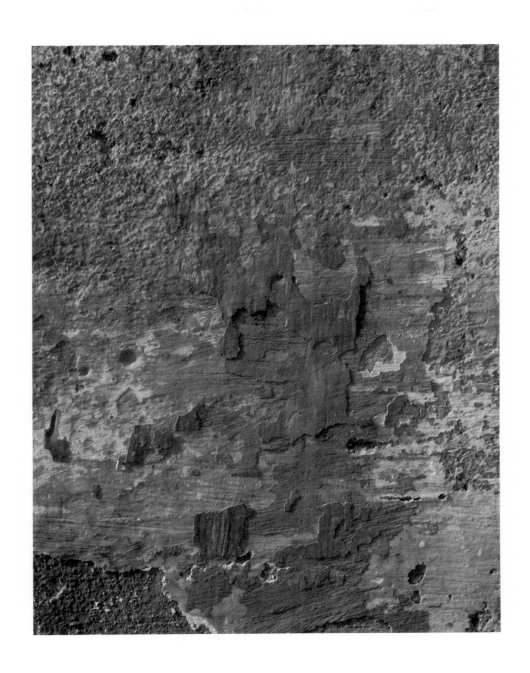

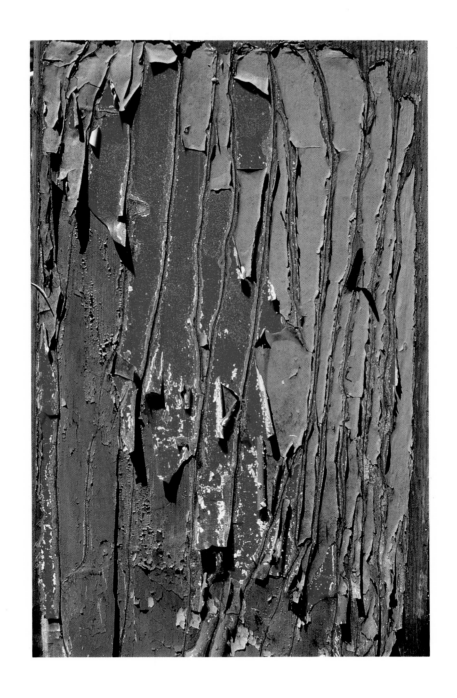

91

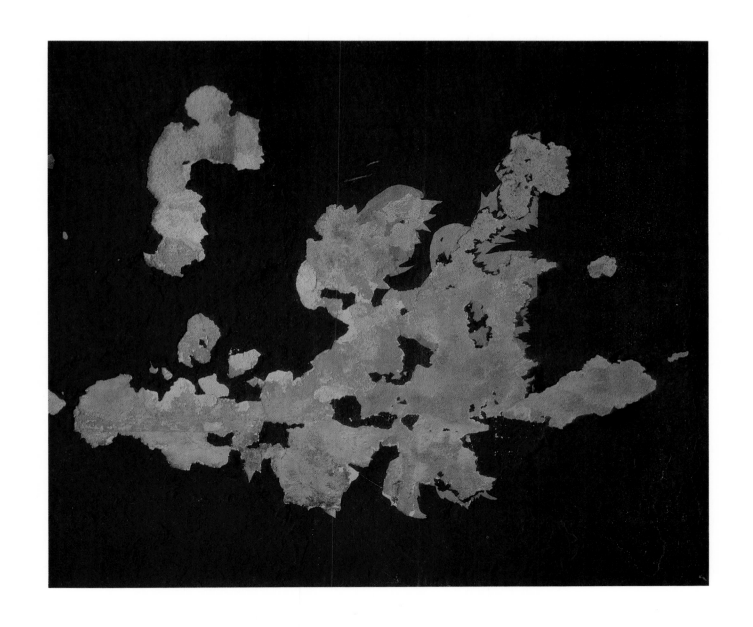

posters & signs

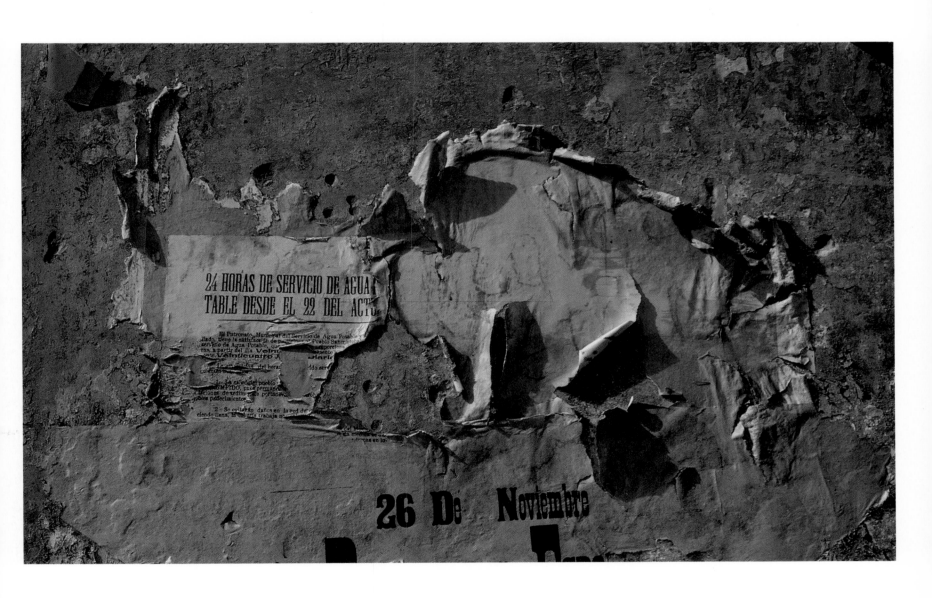

97

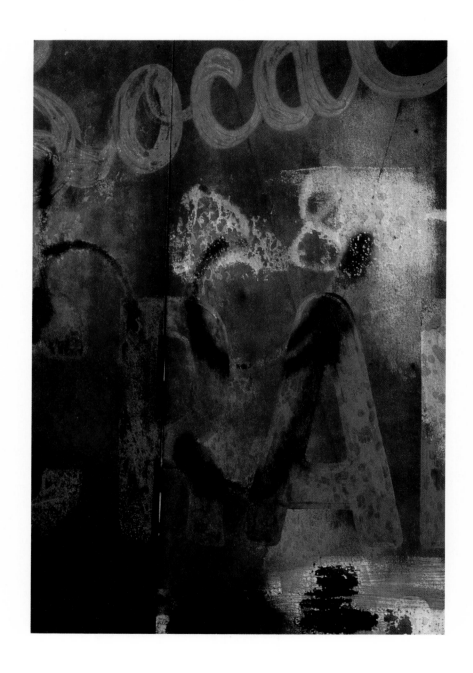

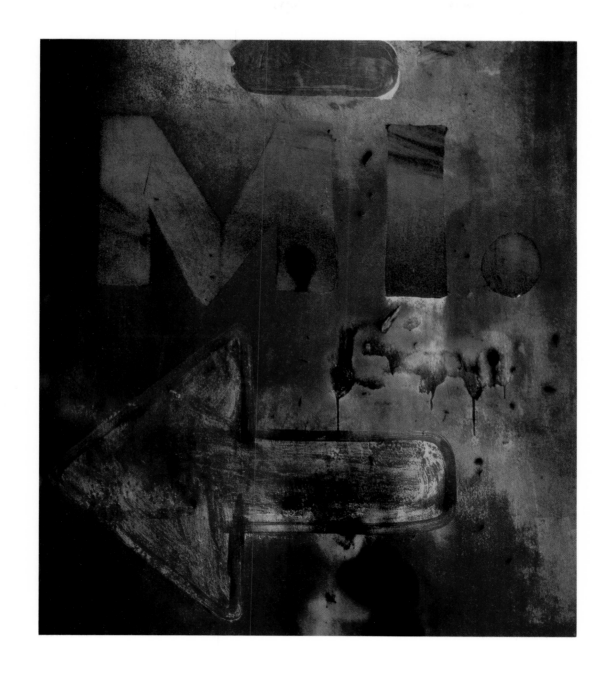

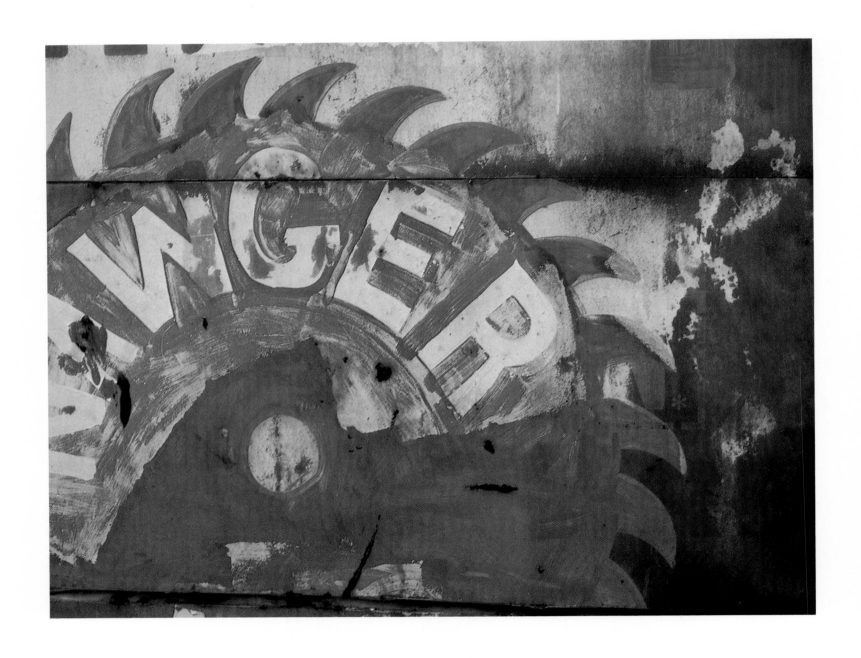

100

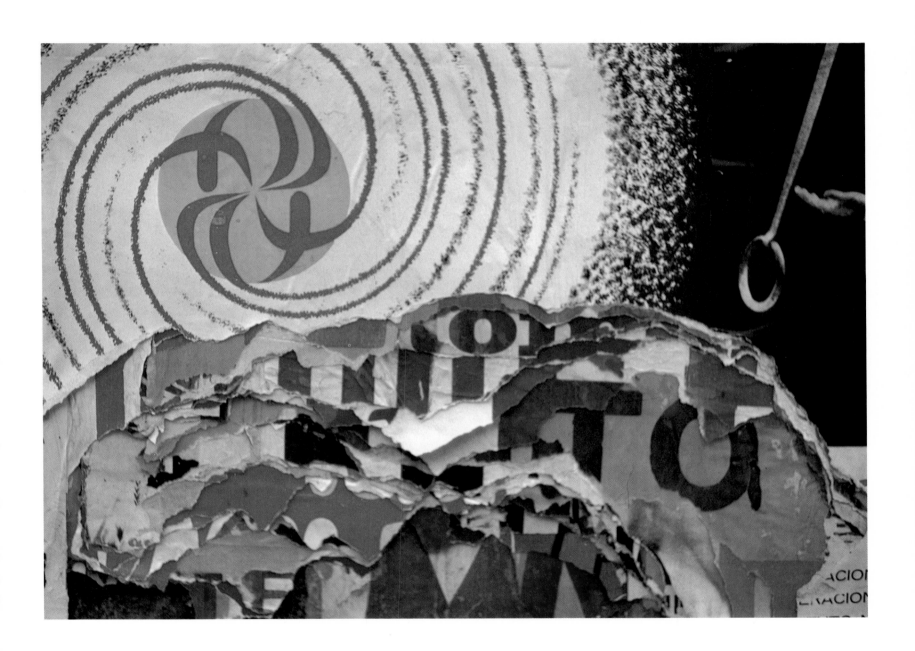

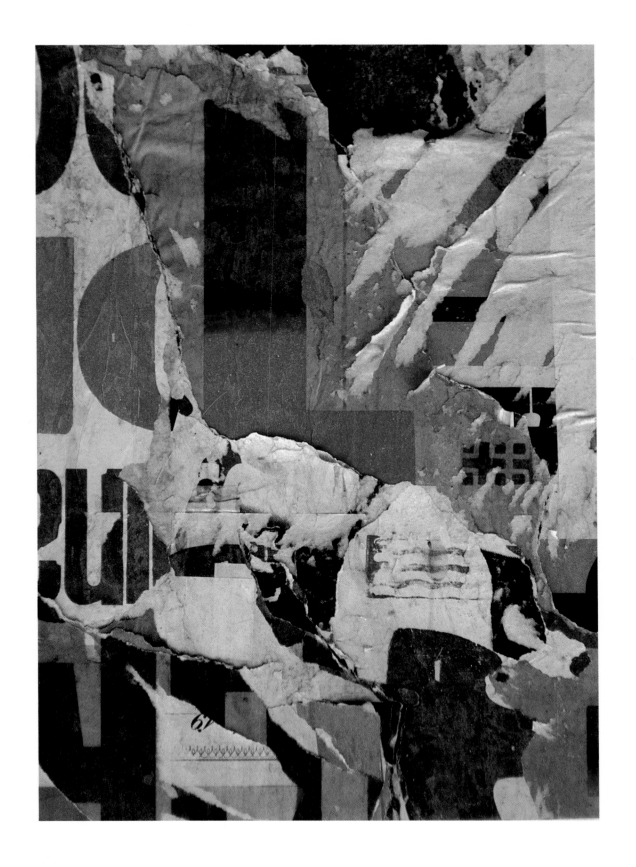

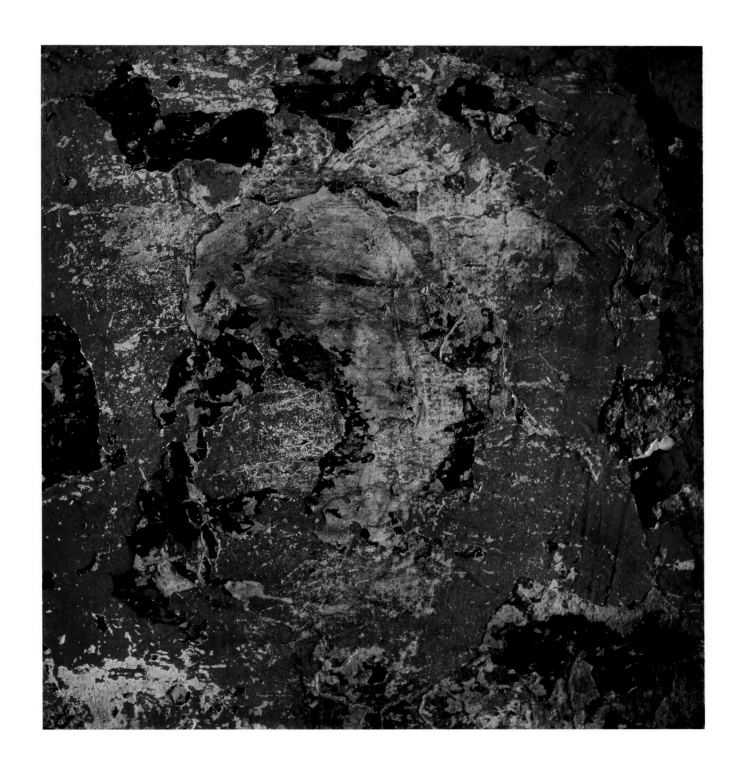

asphalt _____

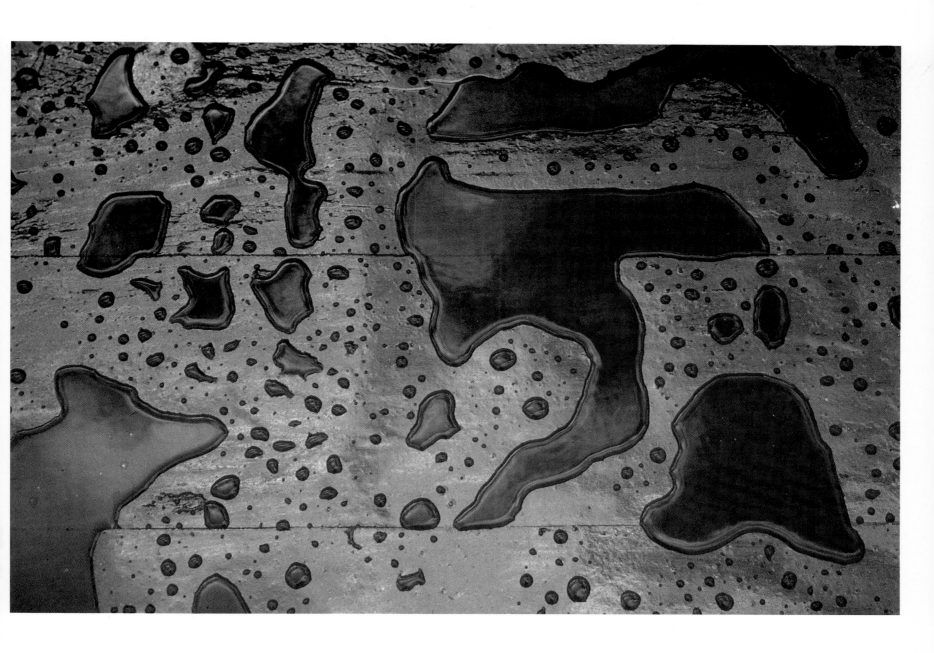

109

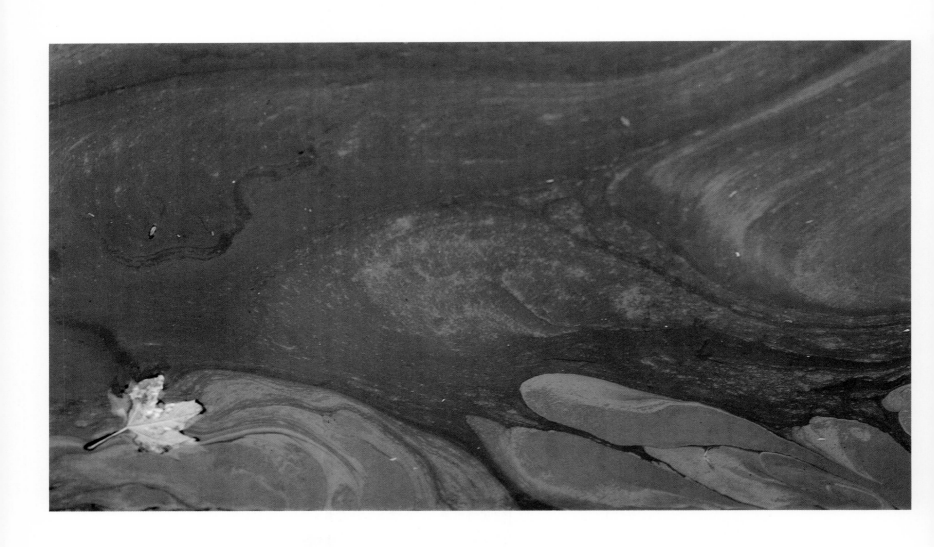

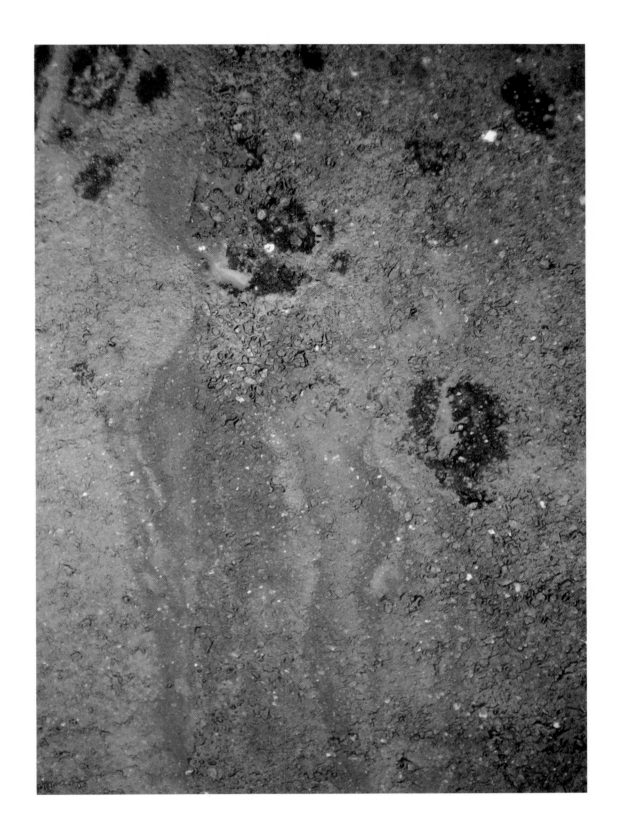

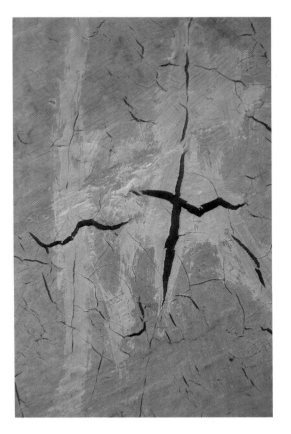

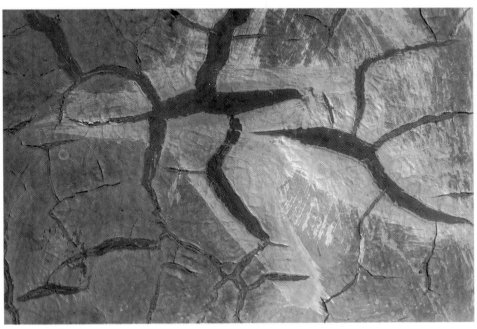

rust_____

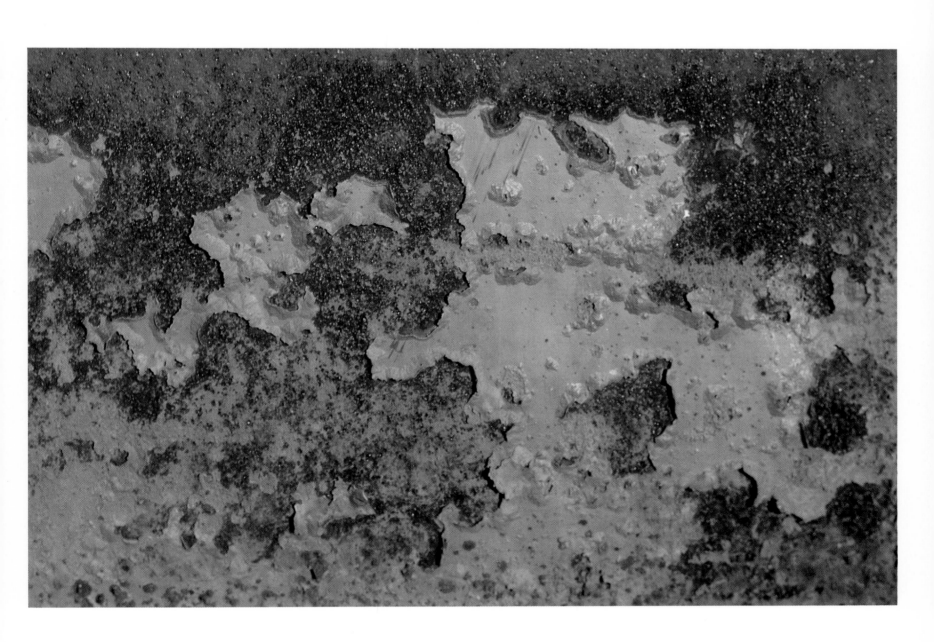

117

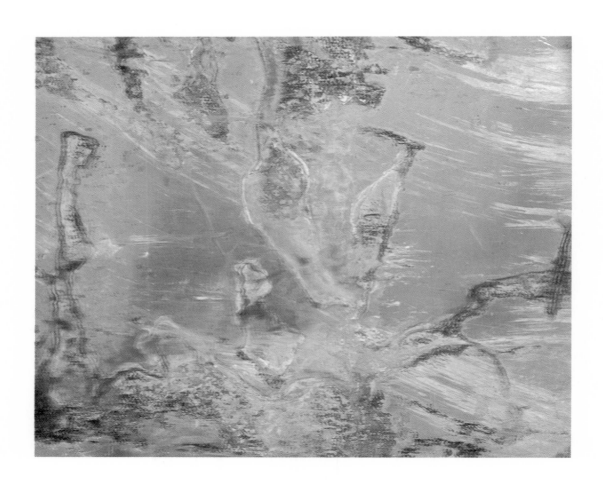

118

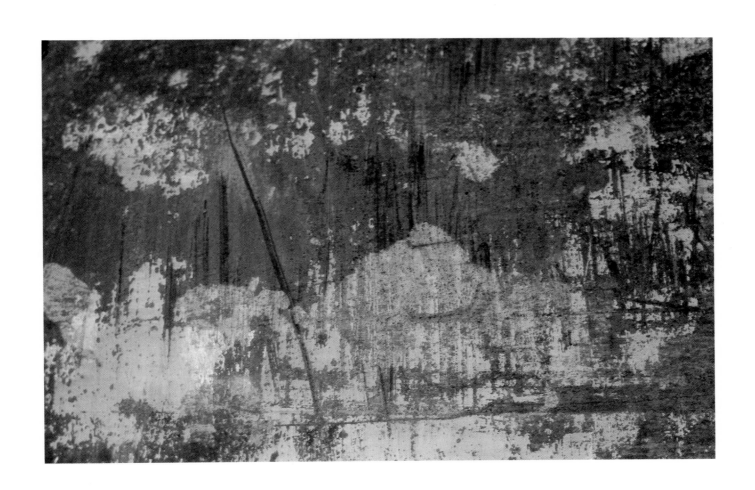

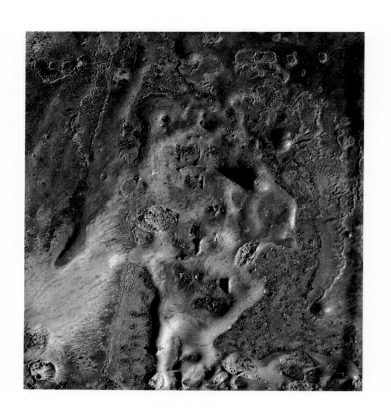

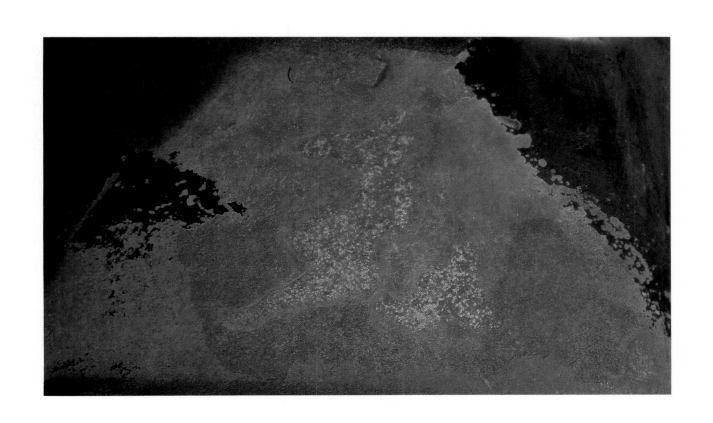

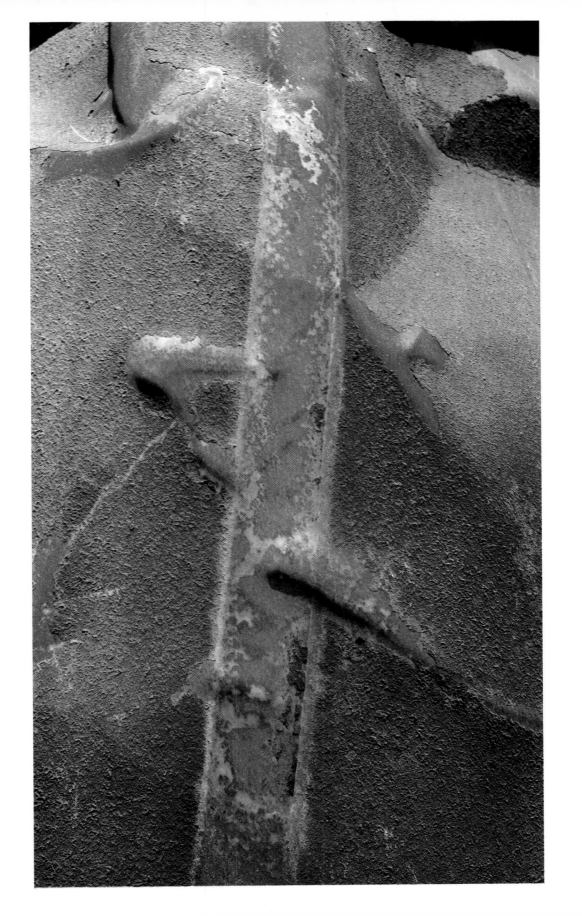

123

TECHNICAL INFORMATION _____

ALL THE PHOTOGRAPHS in this book were made with Leica rangefinder 35mm cameras and with 2¼ x 2¼ Rolleiflexes with 75mm Zeiss Tessar f/3.5 lenses.

We usually carry two Leicas and one Rolleiflex because we enjoy having a choice of two formats, of working with several different emulsions, and the security of back-up cameras. Our equipment for the Leicas includes the 50mm Summicron f/2, the wide-angle 35mm Summaron f/3.5, Leitz Universal Viewfinder, and a close-up attachment, adapted to range- and viewfinder, which makes it possible to close in to 19 inches.

The only filters used were skylight, UV filter, neutral density, and polarizing filters.

We do not use flash outdoors but frequently make use of the amazing light-reflecting power of sheets of crumpled aluminum foil. Controlling the direction and strength of foil-reflected light is extremely simple, eliminating the risk of competing with the prevailing light source. Foil can also be used to good advantage in shading small areas when direct sunlight might "drown" subtle gradations of color. It has the further advantage of being practically without bulk and weight—points that rank high on our list of desirable qualities for the equipment we use, aside from simplicity.

In the mountains and on the seashore, high winds often make the use of tripods impractical. Instead, we have frequently substituted suitable rocks, tree stumps, and each other as a means of solid support for our cameras.

We prefer to use hand-held exposure meters and have relied on Gossen meters and a cherished Weston Master V. Occasionally, we override the meter in order to obtain more, or less, saturated tones than strict obedience to the readings would give us. We find it essential to give the most advantageous exposure to the most important area of the image, and, rather than average the exposure, to decide to sacrifice detail either in the highlights or in the darkest tones when dealing with a subject that exceeds the contrast range of the film.

Films used included: Kodachrome II, K 25, Ektachrome X, Ektachrome Professional, High Speed Ektachrome, and, less frequently, various Agfa films.

In size, our subjects range from 8 x 12 inches to 400 x 400 feet; however, the vast majority measure from 11 x 14 inches to 4 x 4 feet.

TITLES AND PHOTOGRAPHIC DATA

NOTE: The term "Rolleiflex" stands for 2¼ x 2¼ Rolleiflex twin lens with 75mm Zeiss Tessar f/3.5 lens, and the term "Leica" for Leica 35mm rangefinder with 50mm Summicron f/2, unless otherwise indicated.

water

15 Seashore, Maine, 1957. Bright sun. Rolleiflex, polarizing filter, Ektachrome X.

16 Mountain Creek, Glacier National Park, Montana, 1966. Rolleiflex, Skylight filter IA. Fast shutter speed to "freeze" water pattern, bracketing used.

17 (top left) Stream, Great Smoky Mountains National Park, Tennessee, 1980. Leica, Kodachrome 25. Slow shutter speed to allow for some blending of tonalities.

(top right) McDonald Creek, Glacier National Park, Montana, 1966. Leica, Kodachrome II. Shutter speed as in #16.

(bottom) Water, Late Afternoon, Rocky Mountain National Park, Colorado, 1962. Leica, Kodachrome, fast shutter speed as in #16.

19 Water Whirl and Dogwood, Hudson Valley, composite print, 1968. Rolleiflex, Ektachrome X. Subjects of the two images used in print located within 15 feet of each other. Since composite print was planned, both slides were slightly overexposed. In enlarging, the dogwood leaves were deliberately rendered somewhat blurred.

21 Reflection, Canadian Rockies, 1975. Leica, Kodachrome II. This slide has been rotated 90 degrees to achieve the desired image.

stone

25 Erosion Pattern, Glacier National Park, Montana, 1963. Rolleiflex, Ektachrome X, late morning, UV filter.

26 Brown Rock, Glacier National Park, Montana, 1976. Shade. Leica, Ektachrome X, aluminum foil used.

27 Rock Face, Glacier National Park, Montana, 1963. Rolleiflex, Ektachrome X, UV filter. Design literally underfoot on trail.

28 Stones, Bow Glacier, Canadian Rockies, 1979. Leica, close-up attachment. Bright overcast. Kodachrome 25.

29 Split Rock, Glacier National Park, Montana, 1966. Rolleiflex, Ektachrome X, UV filter. Sun overhead gave good definition as rocks were perpendicular.

31 Stone Slab, Glacier National Park, Montana, 1969. Leica, Ektachrome X. The shaded slab stood in a stream that reflected light.

32 Tide Erosion I, Oregon Coast, 1964. Leica, 35 mm Summaron f/3.5, Kodachrome II.

33 Tide Erosion II, Oregon Coast, 1964. Same as #32.

34 Eroded Rock, Glacier National Park, Montana, 1963. Leica, Kodachrome II.

35 Rock Pattern, Rocky Mountain National Park, Colorado, 1963. Leica, Kodachrome II. Sky heavily overcast.

36 Oxidized Rock, Oregon Coast, 1964. Leica, Kodachrome II.

37 Petrified Algae in Blue Siyeh, Glacier National Park, Montana, 1963. Leica, close-up attachment, Ektachrome X. The photographers had to stand on the narrow ledge of a huge boulder, supporting each other.

39 Rock Wall, Zion National Park, Utah, 1965. Rolleiflex, Ektachrome X, polarizing filter.

41 Rock Formation, Oregon Coast, 1964. Rolleiflex, Ektachrome X. Late afternoon, exposed for highlights.

lichen & algae _____

trees _____

walls & sidings _____